Painting Watercolor Portraits

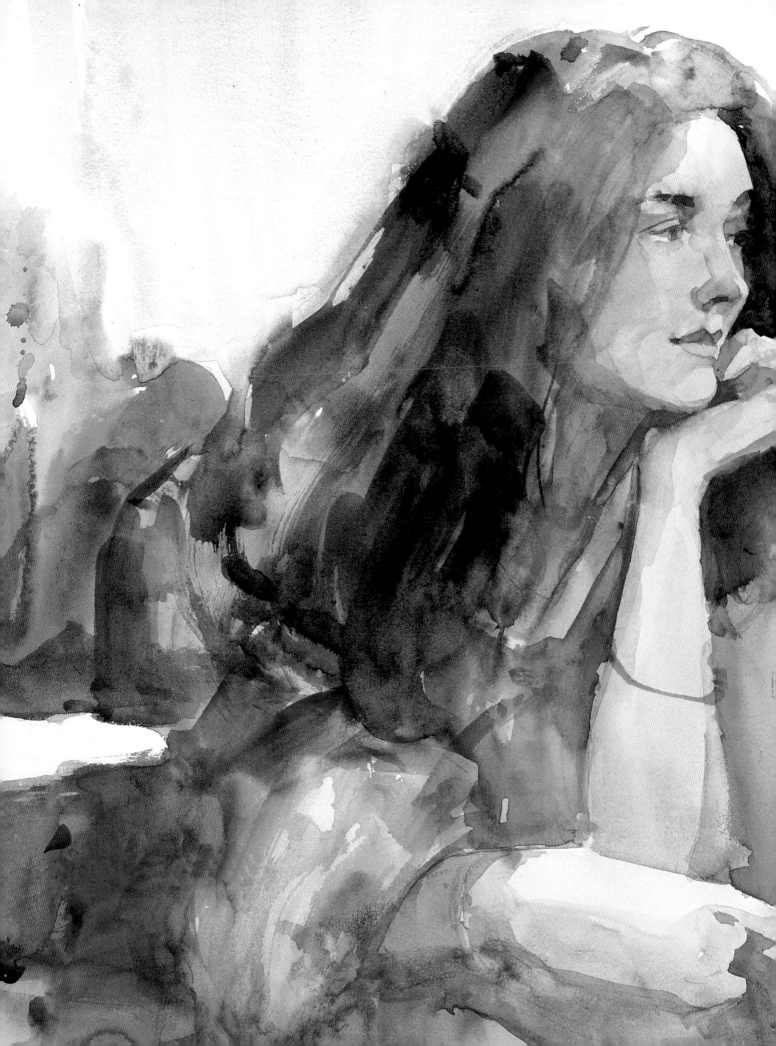

Painting
Watercolor
Portraits

Al Stine

NORTH LIGHT BOOKS
CINCINNATI, OHIO

Acknowledgments

Having done one book for North Light, I was aware of the time and work that goes into it, yet I had the desire to do a book on painting the head and figure in watercolor. As before, I feel I have learned more preparing this book than anyone who will read it. All of the material lay in the back of my mind for years, and it took much study and concentration to bring it all into focus and put it on paper. When asked by students how to improve their painting, I tell them to draw and paint, draw and paint, draw and paint.

I owe a great deal to the encouragement I've received from the people who have studied and painted with me along the way. I also owe thanks to the talented artists I've admired and for the knowledge they have passed on to me.

I would like to extend my thanks to Rachel Wolf for her help as my editor, to Kathy Kipp for her editorial help and encouragement, and to the design team and production staff for their help in putting everything together. A book is certainly a team effort, and I thank them all.

Painting Watercolor Portraits. Copyright © 1997 by Al Stine. Printed and bound in Hong Kong. All rights reserved. No part of this book may be reproduced in any form or by any electronic or mechanical means including information storage and retrieval systems without permission in writing from the publisher, except by a reviewer, who may quote brief passages in a review. Published by North Light Books, an imprint of F&W Publications, Inc., 1507 Dana Avenue, Cincinnati, Ohio 45207. (800) 289-0963. First edition.

Other fine North Light Books are available from your local bookstore, art supply store or direct from the publisher.

01 00 99 98 97 5 4 3 2 1

Library of Congress Cataloging-in-Publication Data
Stine, Al.
 Painting watercolor portraits / by Al Stine.
 p. cm.
 Includes index.
 ISBN 0-89134-641-4 (hc : alk. paper)
 1. Watercolor painting—Technique. 2. Portrait painting—Technique. I. Title.
ND2200.S75 1996
751.42'242—dc20 96-25746
 CIP

Edited by Rachel Wolf
Designed by Sandy Conopeotis Kent

North Light Books are available for sales promotions, premiums and fund-raising use. Special editions or book excerpts can also be created to specification. For details, contact: Special Sales Manager, F&W Publications, 1507 Dana Avenue, Cincinnati, Ohio 45207.

METRIC CONVERSION CHART		
TO CONVERT	**TO**	**MULTIPLY BY**
Inches	Centimeters	2.54
Centimeters	Inches	0.4
Feet	Centimeters	30.5
Centimeters	Feet	0.03
Yards	Meters	0.9
Meters	Yards	1.1
Sq. Inches	Sq. Centimeters	6.45
Sq. Centimeters	Sq. Inches	0.16
Sq. Feet	Sq. Meters	0.09
Sq. Meters	Sq. Feet	10.8
Sq. Yards	Sq. Meters	0.8
Sq. Meters	Sq. Yards	1.2
Pounds	Kilograms	0.45
Kilograms	Pounds	2.2
Ounces	Grams	28.4
Grams	Ounces	0.04

About the Author

Al Stine, MWS, ASMA

Al is a graduate of the Chicago Academy of Fine Art with additional studies at the School of the Art Institute of Chicago. He was a freelance illustrator in Chicago until moving to South Carolina in 1989. Al is a signature member of the Midwest Watercolor Society and an artist member of the American Society of Marine Artists.

Al teaches, judges shows and gives workshops across the United States, Canada, Mexico and Spain. The recipient of numerous awards, his paintings are in many galleries and in private and corporate collections around the world.

Dedication
I dedicate this book to my wife, Liz. Without her help organizing and typing the material—besides being my best critic—this book would not have been possible. ☙

Table of Contents

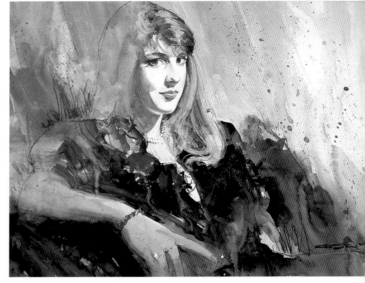

1 Basic Supplies

All of the materials used to draw and paint the figure and head, including demonstrations of various papers.

2 Improving Your Drawing Skills

How to practice contour drawing and drawing with your brush to gain skills.

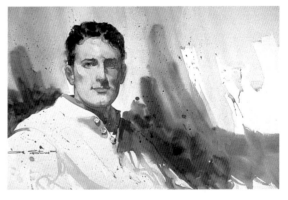

3 Painting Lifelike Facial Features

Demonstrations of individual features and hair, and how to put them together.

4 Mixing Beautiful Skin Colors

Five demos show how to mix skin colors for different complexions.

page 40

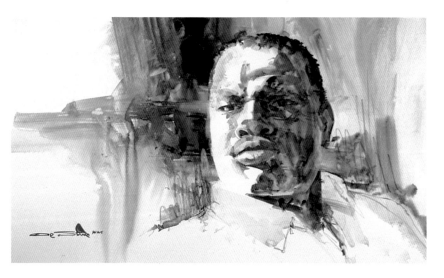

5 Lighting the Pose

How to develop shape and form with lighting.

page 56

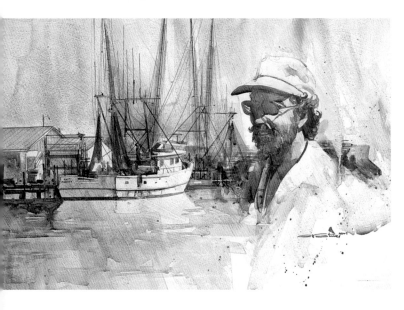

6 Designing the Head and Figure Into a Painting

Twelve demonstrations show you how to compose an exciting painting centered on the head or figure.

page 66

Introduction

My editors and I agree that a picture is worth a thousand words. Therefore, we have attempted to use less text in favor of more steps in each demonstration, and more descriptive captions. We feel that showing step by step how a painting is done is easier to grasp than telling you how to do it.

I have tried to include a little bit of everything I know on these pages, hoping you will be able to take this information and apply what you like to your work. Your goal should not be to paint like I do; the world does not need two people who paint alike. Rather, I hope this book will challenge you to continue studying this complex subject matter, and that it will inspire you and get your creative juices flowing.

1 Basic Supplies

What are the proper materials? This can be confusing for the beginning watercolorist. Many people are natural collectors and seem to accumulate every gadget that comes along. If your pocketbook can afford it, I see nothing wrong with this. I have to admit that I'm one of those collectors. I am always experimenting and have acquired many materials over the years. For our purposes, however, I will only discuss the materials that are essential for the beginner to have.

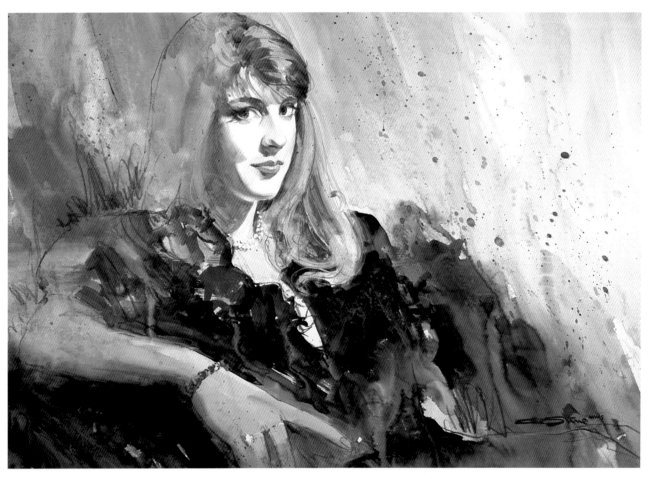

Courtney (20″ × 28″),
in the collection of
Dr. & Mrs. Jeffrey Stevens,
Anderson, South Carolina

This was a commissioned painting done on 2-ply plate finish bristol board. Courtney is a beautiful girl and I wanted to capture her beauty without doing a tight painting. I melded the figure into the background, bringing all focus to her face, a technique that works well on the smooth surface of bristol board.

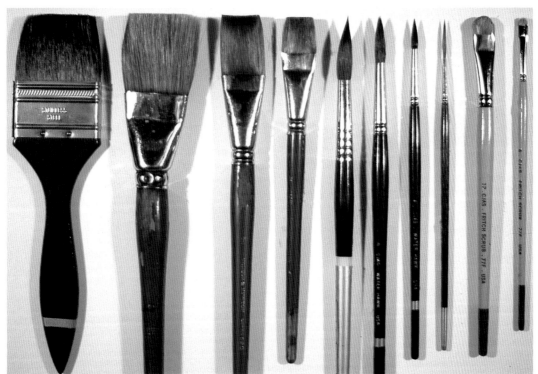

This photograph shows the brushes I use regularly. From left to right: 2-inch sky-flow brush, 1½-inch flat, 1-inch flat, ¾-inch flat, no. 12 round, no. 8 round, no. 4 round, rigger and the last two are scrubbers. There are many other brushes that I use from time to time, but these are the essential brushes I use every day.

Brushes

If I had to choose which of my materials should be of the finest quality, it would be my brushes. The following is information on a selection of brushes with a wide range of costs.

FLATS

There are many brushes on the market that are suitable for painting in watercolor and just as many prices. You can spend over $100 for a no. 8 round Kolinsky sable in one brand, or as little as $23 in another brand. Needless to say, the more expensive brushes are generally better. But there are exceptions, and some of the less expensive brushes work quite nicely. There are also brushes made of natural hair such as fox or squirrel. These brushes are less expensive with a no. 8 running around $7. I recommend purchasing the very best brushes you can afford.

With proper care, the better the brush, the longer the life of the brush. Never use your sable brushes in acrylics or oils since this will quickly ruin them. If you are going to paint in a medium other than watercolor, use synthetic fiber brushes made for that purpose.

I use many synthetic brushes, generally flats. I use a 2-inch sky-flow brush and other flats ranging from ¼-inch to 1½-inch, some synthetic and some natural hair. A synthetic flat will do the job. However, if you can afford it, a flat with some natural hair works better and a sable works best.

ROUNDS

My round brushes range from a no. 4 to a no. 12, and my preference is Kolinsky sable. Sable brushes hold more liquid than synthetic brushes, and they hold the liquid better. Synthetic rounds have a tendency to drip on the way to the paper, releasing the liquid quickly and often making a puddle with the first stroke. There are some newer synthetic brushes that are said to come close to natural hair brushes in performance, but I haven't tried them.

SPECIALTY BRUSHES

I use other specialty brushes such as mop brushes, riggers and script liners. A no. 4 sable rigger will cost about twice as much as a synthetic. But a rigger is the one brush that *should* be sable. You don't want to run out of pigment on a long fine line as this error will be obvious in your finished painting.

There are many specialty brushes on the market, but for figures and portraiture I believe those illustrated here will do nicely.

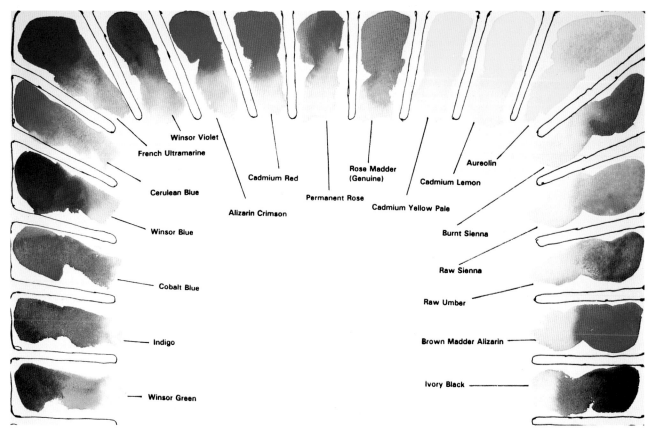

Winsor Violet

French Ultramarine

Cerulean Blue

Winsor Blue

Cobalt Blue

Indigo

Winsor Green

Cadmium Red

Alizarin Crimson

Rose Madder
(Genuine)

Permanent Rose

Cadmium Yellow Pale

Aureolin

Cadmium Lemon

Burnt Sienna

Raw Sienna

Raw Umber

Brown Madder Alizarin

Ivory Black

This is how my palette is laid out when I paint people. The palette I use for landscapes is totally different.

Colors

I use Winsor & Newton Artist Colors almost exclusively. They are ground to a fine consistency and the color doesn't vary from one batch to another. But don't get stuck on them. There are many other fine brands on the market, which I have used from time to time. My palette also changes occasionally as I experiment with new colors.

Like other artists, I generally use two of each basic primary—a warm and cool red, a warm and cool blue, and a warm and cool yellow. From there your palette can take off in its own direction as we all have our favorite colors.

The palette I currently use for painting the head and figure contains nineteen colors. I do not use all of these colors for any one painting. I use a fairly limited palette in a painting, giving me better color harmony throughout the painting. I will discuss each color in more detail in chapter four.

Colors on My Palette

Winsor Green
Indigo
Cobalt Blue
Winsor Blue
Cerulean Blue
French Ultramarine Blue
Winsor Violet
Alizarin Crimson
Cadmium Red
Permanent Rose
Rose Madder Genuine
Cadmium Yellow Pale
Cadmium Lemon
Aureolin
Burnt Sienna
Raw Sienna
Raw Umber
Brown Madder Alizarin
Ivory Black

Papers and Boards

I have experimented with many surfaces over the years and will probably continue to do so. I currently use Arches 140-lb. cold press, Arches 140-lb. hot press, Strathmore 2-ply plate finish bristol board, Crescent #112 rough watercolor board, and gessoed Aquarius watercolor paper. Examples and discussion of each surface follow.

ARCHES 140-LB. COLD PRESS

This paper has texture, and although it is possible to move paint around on it to a limited degree, the pigment tends to stay where you place it. You can achieve a soft look by laying in color and then spraying it with water, allowing the color to run. This technique works well on this paper although the color does not run as much as it does on other papers such as bristol board. I generally soak and then staple this paper to a board, allowing it to dry completely before painting. This gives me the tight surface I prefer.

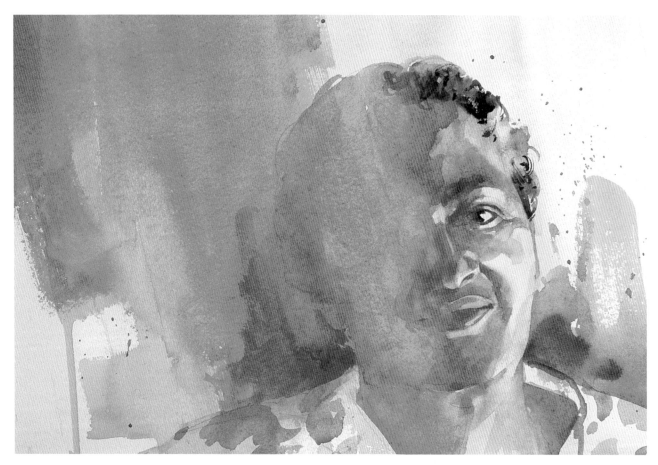

Betty Ruth (14" × 21")

Soft Effect
When working on Arches 140-lb. cold press paper, I get a softer effect than I do on any other surface. Here I used the triad of Aureolin Yellow, Rose Madder Genuine and Cobalt Blue. I wanted the left side of the head to be diffused and to blend into the background, leaving the center of interest on the right side.

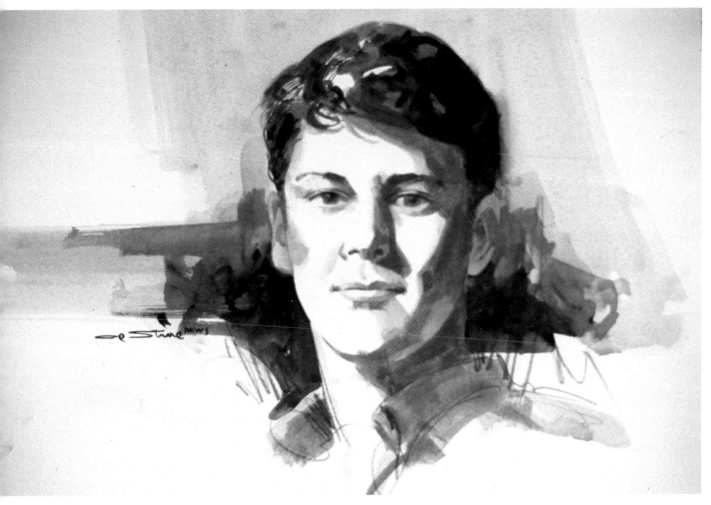

Scott (10″ × 13″)

Harder Edges

Scott was painted on Arches 140-lb. hot press paper. Pigment sinks into this paper very quickly and if you want to soften edges, you have to do that before they dry. I began by painting the left eye and used that to judge all the other values. The colors I used for the skin were Raw Sienna, Raw Umber and Permanent Rose. The darks were achieved with some Cobalt Blue and Brown Madder Alizarin, and the lightest values are the white of the paper.

ARCHES 140-LB. HOT PRESS

When using this paper, I do not soak and stretch the paper as I do with the cold press. This removes too much of the sizing, and the paper begins to act like a blotter, which makes it difficult to move paint around or to soften edges. Instead, I do my drawing on the paper and then, before painting, I either staple the dry paper to a board or hold it in place with clips at the four corners. There is a visible difference in the appearance of the colors on the hot press versus those on the cold press paper.

I did not always enjoy working on smooth-surfaced papers, but I find I'm using them more often. You can achieve some exciting effects and color lifts more easily than you can on cold-press pa-pers. I like the way you can move color around on the smooth surface. Even when using a round brush, you can lay the brush on its side and drag and scrape the colors for exciting movement and texture. Rather than damage a good sable brush for scraping, I use an old brush that has lost its point. Save your old brushes for this purpose.

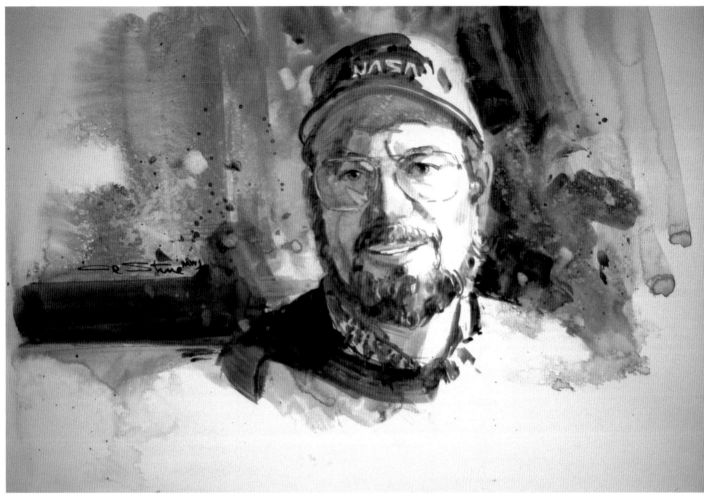

Don (10″ × 13″)

Smooth Surface
You can see the wonderful textural effects in the background that can be achieved on the plate finish bristol board. These blobs, splashes and spontaneous blendings are possible because the paint sits right on the hard surface. Lifting areas is also easy since the colors don't sink in. Here I used Raw Umber and Alizarin Crimson for the skin color. I also used these two colors in the background adding Brown Madder Alizarin and Indigo for the darks.

STRATHMORE 2-PLY PLATE FINISH BRISTOL BOARD

I enjoy working on the plate finish bristol boards and find them very exciting. I've had a lot of failures, more so than on cold press and hot press, but the results are worth the struggle. One reason for the larger number of failures is that the surface is unpredictable, and it takes a lot of experimenting to understand how the colors will react. You can apply color to this surface and spray with water, causing the colors to run and creating wonderful effects. Both sides of this board can be used (in case of failure), and I either staple or clamp it to a painting board. As on the hot press, you can use a round brush to drag and scrape the colors for varied textures.

CRESCENT #112 ROUGH WATERCOLOR BOARD

The surface of this board has a little texture, and even though they call it rough, it's still not as rough as the Arches 140-lb. cold press. Colors lift very nicely from this board, which is great if that is your intent. But be careful not to disturb an underlying color when going over it with another. You must have a light touch with your brush—good advice no matter what surface you're working on. If you use white artist tape for masking, be careful when lifting the tape to avoid picking up paper along with it. I lay my tape on a paper, lifting it repeatedly until I have removed some of the stickiness. This helps alleviate the problem.

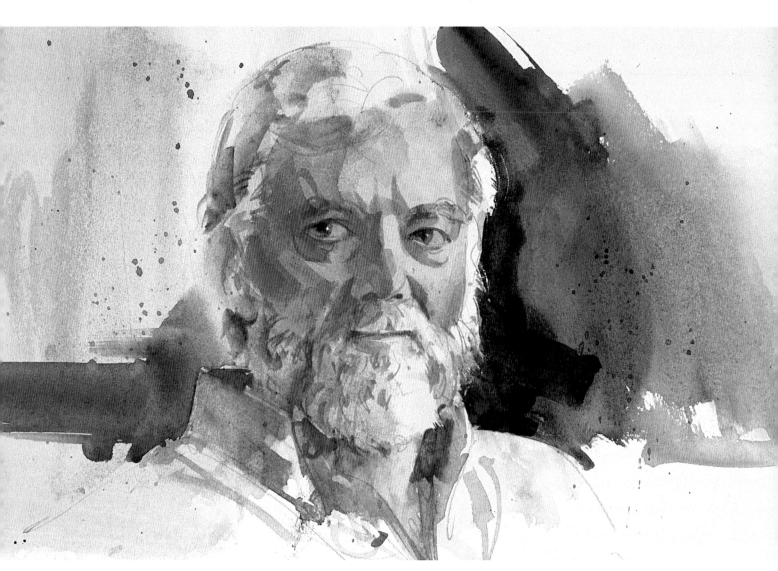

Peter (10" × 13")

Washes Easily
After starting this painting I didn't care for the way it was going, so I washed all the colors out and started over. Color washes easily off this board because the pigment rides on the surface rather than sinking in. This is the advantage of working on this surface. I used Raw Sienna and Alizarin Crimson for the skin tones with some Cobalt Blue added for the darks.

GESSOED SURFACES

If you like to experiment with different techniques, you might enjoy working on a gessoed surface. I use Aquarius watercolor paper and give it a coat of gesso with a 2-inch to 3-inch brush, making a random pattern with my brush strokes. I allow the surface to dry completely before making my drawing, and then apply color. It takes a bit of practice to get the feel of how color reacts on the surface when using this technique. A trick you might try is adding soap to the paint. This cuts the surface tension, allowing the paint to adhere to the surface. To do this, I wipe my brush on a bar of soap and then pick up the color to apply it to the paper.

The more I paint on this surface, the more I like it. As with everything, practice will make you more comfortable and successful.

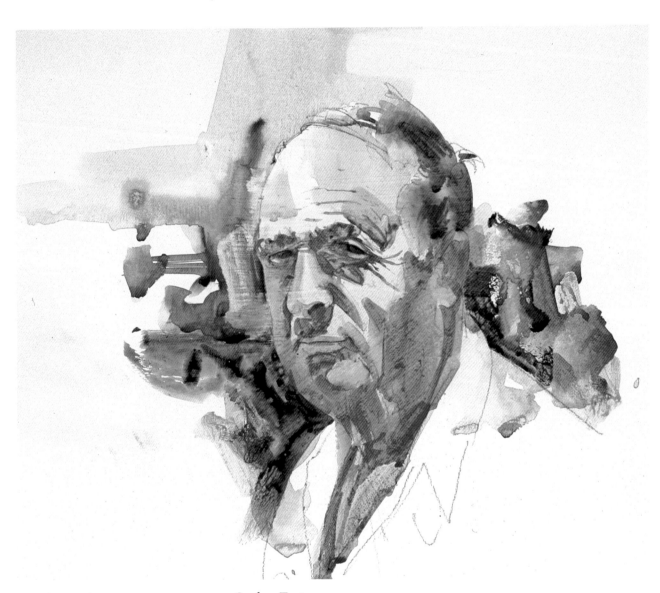

Owen (10″ × 13″)

Surface Texture
I began painting on this gessoed coated paper by applying the skin colors, washing the edges into the background and up into the hair. I used Raw Sienna, Alizarin Crimson and some Raw Umber for the skin tones. Note the brushstrokes of the gesso application through the transparent colors. The nice thing about working on a gessoed surface is that you can wash it down to the white of the paper and begin over if necessary.

2 Improving Your Drawing Skills

Whether drawing from your photographs or a live model, there are two methods that can improve your drawing skills and help you loosen up. The first method is using a brush to draw rather than a pencil or pen. This is a marvelous way to develop dexterity with your brush. The second method is contour drawing. Again, the more you practice these skills, the better you become. I also develop my skills by meeting with other artists in our area once a week to draw and paint from a live model. We work in different mediums—from pencil to watercolor. Perhaps you can find a similar group in your area. You don't need an instructor. Simply chip in enough money to cover the model fee.

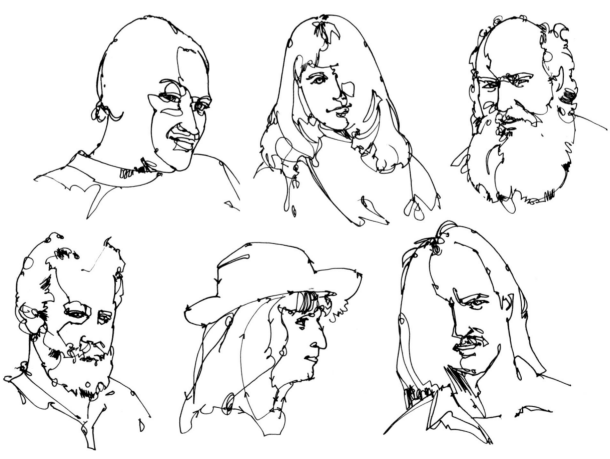

With little exception, these contour drawings were accomplished without lifting the pen from the paper.

Contour Drawing

Contour drawing has been most helpful in teaching my students to draw better. One student, who is becoming a fine painter, says this method has helped him more than anything else he has learned about drawing. The line and character of his drawing has improved greatly.

KEEP PEN OR PENCIL ON PAPER

The objective of contour drawing is to keep the pen or pencil on the paper as much as possible without lifting it, all the while looking at the subject you are attempting to draw. In true contour drawing you will never look at the paper,

only at the subject. Exciting shapes can be achieved with this method and it prevents your work from getting tight, thus looking like a photograph.

DRAW SHAPES

Don't draw things, draw shapes. On a contour drawing, you can begin drawing anywhere but I generally begin with an eye. I do this more from habit than for any other reason and it seems to work best for me. When I begin, I think entirely about the shapes I see rather than the eye itself. After working out this area, I move on to other parts and use the eye I

have just finished to judge the rest of the drawing for shapes, sizes, angles and proportions.

USING A PEN

Using a pen will give you clean lines and will eliminate the habit of reaching for the eraser. I sometimes work with a Tombow pen that has a fine or very fine point. The surface I work on determines which one I choose. For instance, if I'm working on vellum or some other smooth surface, I use a very fine point; if I'm working on a surface with more texture, I use a fine to medium point to get a heavier line.

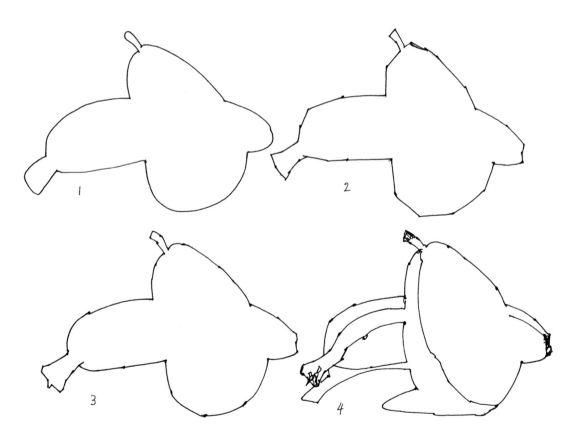

Four Kinds of Contour Drawing
In the first drawing of the pear and banana, I used only curved lines, not lifting the pen from the paper and keeping my eye on the subject as much as possible. In the second drawing, with the same technique, I used only straight lines. Both drawings are boring because there is too much "sameness." In the third example, I used both curved and straight lines to get more variation into the drawing. Finally, in the fourth drawing, I added some interior lines that develop shadow areas. I also connected the drawing to the background with the use of cast shadows.

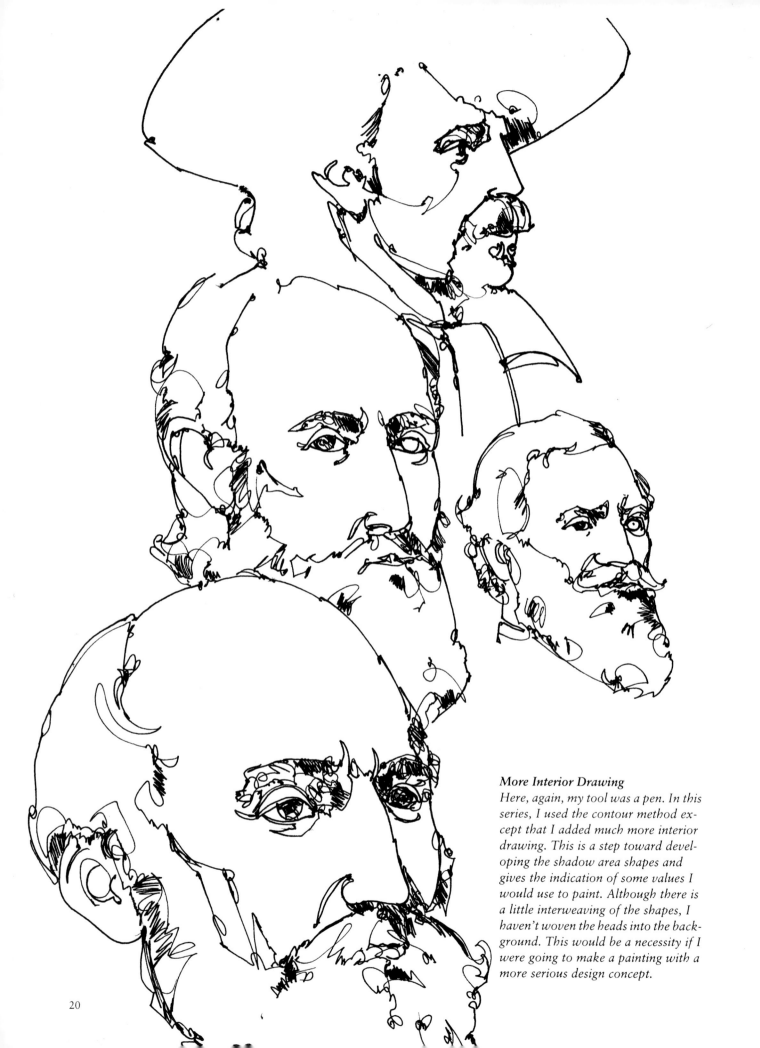

More Interior Drawing
Here, again, my tool was a pen. In this series, I used the contour method except that I added much more interior drawing. This is a step toward developing the shadow area shapes and gives the indication of some values I would use to paint. Although there is a little interweaving of the shapes, I haven't woven the heads into the background. This would be a necessity if I were going to make a painting with a more serious design concept.

WEAVING SHAPES INTO THE BACKGROUND

I know my students tire of hearing me talk about shapes but it's so important. It will help both your drawing and painting. Not only do we need to see and draw the shapes of our subject, but we must look at the shapes that weave through the subject and the background that indicate the lost and found edges. This helps make a drawing that will become a complete painting and not one that looks like it has been cut out and pasted on the surface.

CONTOUR DRAWING TIPS

- Go fast on the straight and curved lines; slow down on the angles.

- Stop often to see where you are and check for shapes, sizes and proportions.

- Try not to repeat the same shape twice. This will add more variety to your drawing.

- Let the pen or pencil linger at a stopping point, making a distinctive mark that adds character to the line.

- Think of the shadow areas as shapes and draw those shapes.

- Draw the background shapes and weave them in and out of the subject. If you draw the subject and then come back later to draw the background, you will have two totally isolated thoughts.

- If a boundary is lost in shadow, then leave it out in the drawing to remind you to leave it out when you do the painting.

- Connect your subject to at least three of the borders, and try to balance the positive and negative shapes to achieve better design.

- Try to keep the backgrounds as simple as possible unless the subject matter demands more involvement.

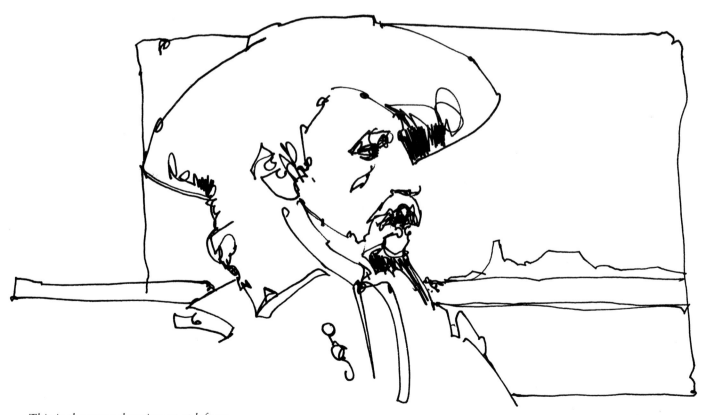

This is the same drawing as at left except that I attempted to weave the figure and the background together in order to achieve a better composition.

DON'T WORRY ABOUT PROPORTIONS

Don't concern yourself too much about proportions, but rather concentrate on the shapes and angles and try to capture the feeling of the subject. I would rather see an exaggerated drawing of the subject—one that shows feeling and captures the character—than one that is too photographic and tight. Contour drawing is a big help for students who do not draw well and haven't had much experience drawing the head and figure. I recommend *Drawing on the Right Side of the Brain* by Betty Edwards for students who are serious about improving their drawing skills. This book shows some examples of students' work at the beginning of practicing the exercises and then again after only a few weeks. The improvement is truly amazing.

This is the photograph of Mindy I used to do the contour drawing below.

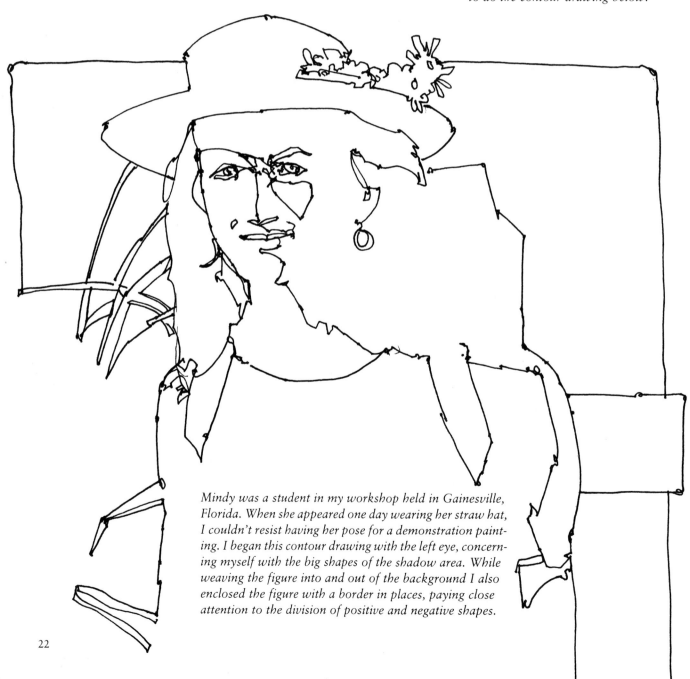

Mindy was a student in my workshop held in Gainesville, Florida. When she appeared one day wearing her straw hat, I couldn't resist having her pose for a demonstration painting. I began this contour drawing with the left eye, concerning myself with the big shapes of the shadow area. While weaving the figure into and out of the background I also enclosed the figure with a border in places, paying close attention to the division of positive and negative shapes.

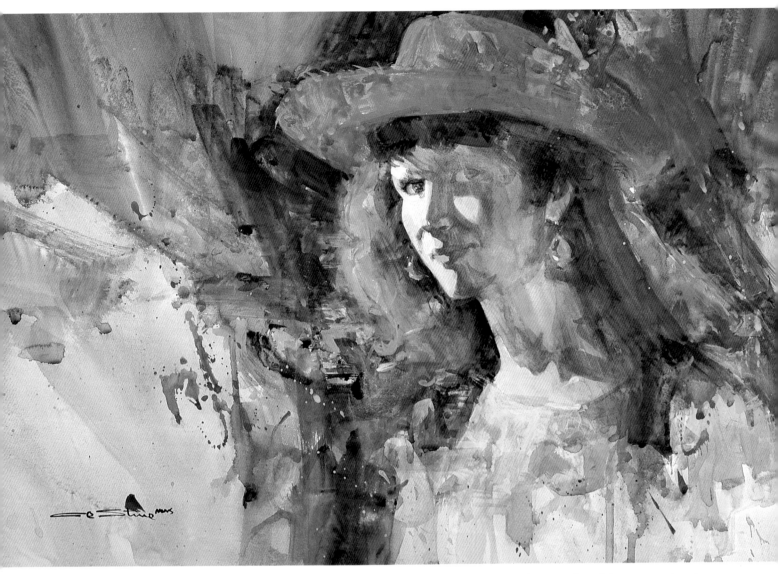

Mindy (14" × 21"),
in the collection of
Mr. & Mrs. Wm. F. Wagner,
Anderson, South Carolina

This painting was developed using both the photograph and the contour drawing as reference. Note that I did not include the backpack and its straps as I felt they added nothing to the painting.

Drawing With Your Brush

My artist friends and I begin the drawing sessions mentioned earlier with one- and two-minute poses, real quickies, which are a wonderful way to loosen up. You may be surprised at what you can put down on the paper in such a short period of time. We then move on to five- and ten-minute poses. I use a brush to do all the drawing, generally a no. 6 or no. 8 sable round. It is difficult to get tight when drawing with a brush during short poses. We finish the sitting with a twenty-five-minute pose. Even during this period I use my brush to draw. Begin with a light value like Raw Sienna, and as the drawing progresses, use more intense color.

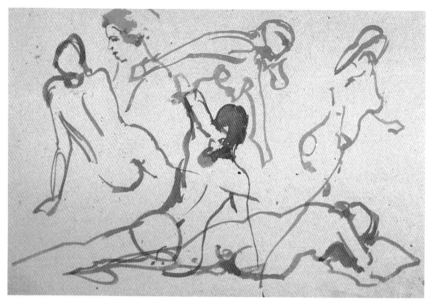

These one-minute poses were drawn with a brush. My goal was to capture the essence of the pose with a flowing line.

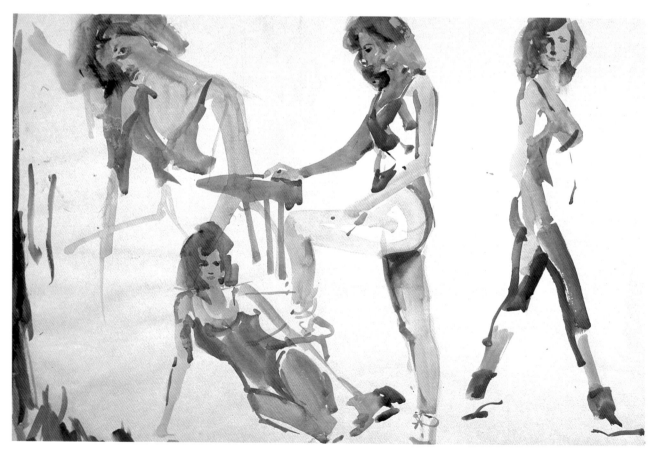

Ten-minute poses allow much more time. In this series I not only drew the figure with the brush but had enough time to add some skin and clothing color. White areas indicate the light source.

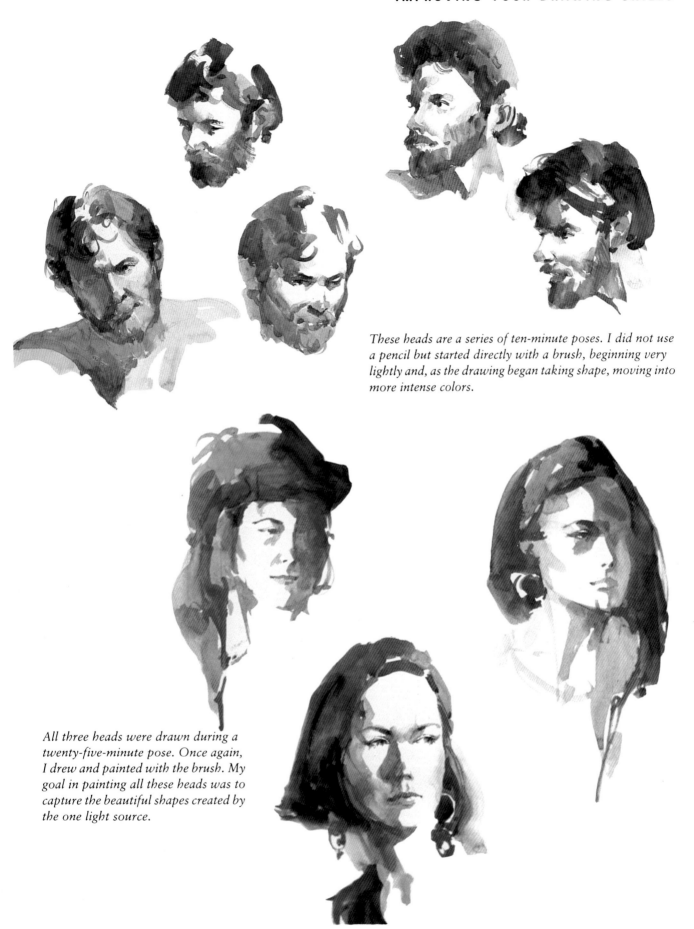

These heads are a series of ten-minute poses. I did not use a pencil but started directly with a brush, beginning very lightly and, as the drawing began taking shape, moving into more intense colors.

All three heads were drawn during a twenty-five-minute pose. Once again, I drew and painted with the brush. My goal in painting all these heads was to capture the beautiful shapes created by the one light source.

3 Painting Lifelike Facial Features

From the beginning, whether man drew on stone or paper, the head has been the most important part of the figure. When you think about someone, you think of their face composed of all its various parts. Everyone has a different face and of all the billions of people on Earth, there are no two perfectly alike. Although twins come close, there are always differences. Many facets make up a person's face and by changing just one facet, we can alter a face tremendously.

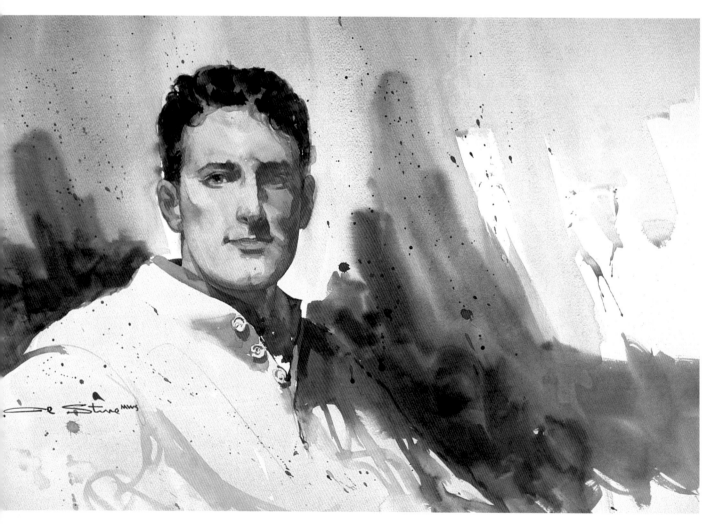

David (19″ × 27″), in the collection of Dr. & Mrs. Carl Geier, Anderson, South Carolina

The Head

Theoretically, the two sides of the head are in perfect symmetry; in reality, the two sides of the face are different. The eyes are not exactly alike, nor are the eyebrows or the corners of the mouth. If you take the right side of someone's face, create a mirror image of that side and then put the two sides together, you will see how strange it looks.

You have been looking at heads and faces all of your life but as an artist, you must become more observant. You must study and compare what makes up a face, what it says to you and what you want to get down on paper. Carry your sketchbook around and sketch your friends and relatives. There is never a shortage of people to draw and, when asked, most are flattered that you wish to draw them. When drawing and painting people for yourself, it is not necessary and sometimes not even desirable to achieve a likeness. But when doing a commissioned portrait, it is not only necessary to achieve a good likeness but to be flattering, eliminating faults. In studying John Singer Sargent's work, you will see that the paintings he did for his own pleasure were not flattering but captured the person's character. However, with his commissioned work, he used a flattering light that made the women beautiful and the men handsome.

We are moved by people's faces, reacting to them, sometimes with tears or laughter. These emotions are what we want to communicate to our viewers—not just a well-painted head, but one that tells a story. In this chapter I want to help you draw and paint better heads with both conviction and solid form.

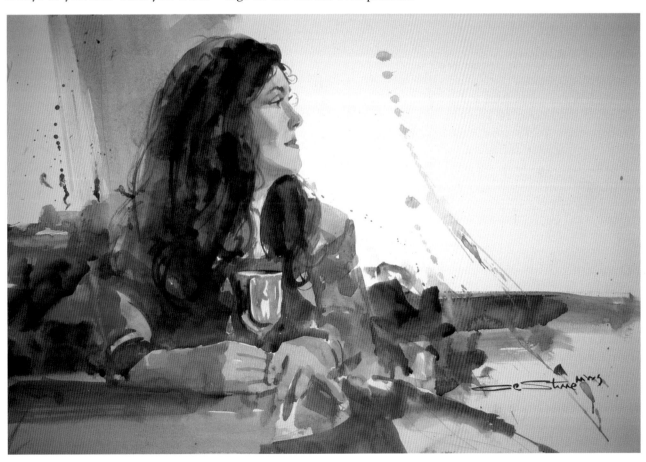

Jill (14″ × 21″)

When doing a side view, keep in mind that the two sides of the face are not symmetrical. The right side will look different from the left side.

The Mouth

The mouth is the second most expressive feature of the face. The shape of the mouth is largely determined by the curvature of the bone and teeth. The most forward part of this curve is at the center of the mouth, and then it curves back toward the cheeks. Correspondingly, the lips are fullest in front and become thinner as they recede. In repose the mouth is fuller than at any other time. No feature is more flexible than the mouth. The upper lip remains fairly stationary while the lower lip moves with the up and down motion of the lower jaw. At the same time, the lips curve into all sorts of common and unlikely shapes.

To draw the mouth correctly, it is helpful to think of the lips as having five muscles: three in the upper lip and two in the lower lip. Vanderpoel, who was considered one of the premier draftsmen of the head, had the muscles reversed placing three in the lower lip and two in the upper lip. However, I believe most contemporary artists agree that the lips are easier to draw with three muscles in the upper lip and two muscles in the lower lip.

There are slight depressions where the corners of the mouth run into the lower cheek. These depressions are usually more pronounced on a man than on a woman. In the frontal view, the convex features of the mouth are affected by the teeth and the corners are farther back than the middle. The curvature of the lips as they near the corners is a bit foreshortened. Always establish the relationship of the corners of the mouth to the middle before going into detail.

When drawing the mouth in profile, notice that the lips usually slope backward on a line from near the tip of the nose to the furrow at the top of the chin.

SOFTEN THE EDGES OF THE LIPS

When painting the mouth, it is necessary to soften the edges of the lips in order to make them look like a natural part of the face. This softening process takes practice and needs to be done while the paint is still wet. If you wait until the paint has dried, it will be difficult to soften and most likely it will take on an overworked look. There are two ways to soften these edges. The first is to rinse your brush in clean water by shaking out the excess water and then touching the brush to the outer edge of the lips, moving it up and away at about a 45-degree angle. The second, and perhaps easier way, is to again rinse the brush in clear water, touch the brush about ½-inch above the lip and then bring the brush down at a 45-degree angle to the edge of the area to be softened. Do only this and get out. Don't try to make it better by tickling it to death. If you are working very juicy and wet, wait a moment longer before softening an edge or it will run too much. This is something that will come only with practice.

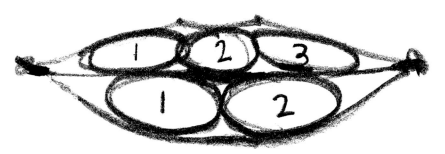

Think of the mouth as having five muscles in the lips: three in the upper lip and two in the lower lip.

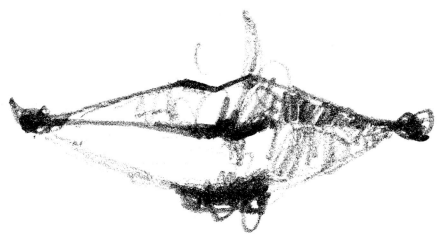

The upper lip is normally darker than the lower lip because the source of light is generally from above and to one side of the head.

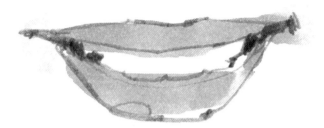

When smiling, the upper lip stays on a flatter plane and is narrower than the lower lip, which with the lowering of the chin, is fuller and more sensuous.

When the head is tilted back, we see more of the teeth, and the upper lip takes on a very distinct curve while the lower lip flattens out quite a bit.

This is a side and three-quarter view of the mouth showing how the various edges are softened into the face.

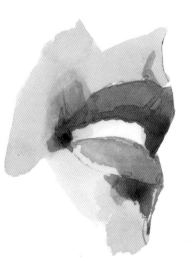

Soften the lipline so the mouth does not look cut out and pasted on. While the paint is still wet you can touch the edges with a clean, damp brush and move away from the lipline, softening it into the face. Or you can move from the face to the lipline allowing the color on the lip to run into the clear water on the face.

The Eye

The eyes are the most expressive features of the face. They can tell our emotions more vividly than words—it is difficult to mask your feelings when someone looks into your eyes. The eyes can express emotions such as anger, disgust, sadness, confusion, happiness and love.

EYEBROWS

The eyebrows follow the upper ridge lines of the eye sockets, emphasizing the mood shown in the eyes. Drawing eyebrows correctly helps create a feeling. I once read that the eyebrows are the exclamation points for the eyes and I have found this to be true. I began my career as a cartoonist and worked in that field for several years; I still do cartoons today for my own enjoyment. Drawing cartoons with their exaggerated features, particularly eyebrows, and myriad of expressions helped me immeasurably in my more realistic drawing. It was great training.

SHAPE OF THE EYE

The shape of the eye is determined by the shape they rest on—that is, the bone structure. Try to feel this as you draw. Your ability as a draftsman lies to some degree in your understanding of the structure of the eye. The eyeball is round; even though you may only see a small portion of the shape, draw it with the sense of that roundness. In addition to the overall shape, there are three parts to the eye that concern us: the pupil, the iris surrounding the pupil and the white of the eye surrounding both. A fourth "part" to remember is the reflection in the pupil. This is caused by a light source hitting the moist area. This highlight is most important, so paint it with care.

THE EYELIDS

The eye has two lids, the upper and lower, both meant for protection. The upper lid has more flexibility and closes over the entire eyeball while the lower lid has only a little mobility. The lids are fringed with lashes, which also protect the eye. Study the work of other artists. Many years ago, I studied the work of such illustrators as Coby Whitmore and Al Parker, who did such beautiful facial features. In one issue of *Cosmopolitan*, Al Parker did *all* of the illustrations—each in a different technique—and signed a different name to each one. He was quite a talent and a truly gifted draftsman.

CORNERS OF THE EYE

There is a difference between the inner and outer corners of the eye. At the inner corner, the lids do not overlap, but there is a U-shaped curve that contains a pinkish membrane. At this point the upper lid rises abruptly and curves over the form of the eyeball, dropping to join the cheek at the outer corner, where it overlaps the lower lid. The lower lid goes from the inner corner of the eye on a relatively flat plane, then rises to fit under the upper lid at the outer corner, which is usually higher than the inner corner.

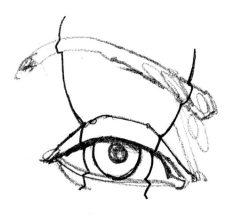

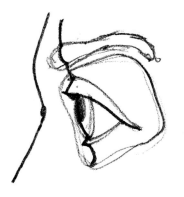

In this frontal and side view of the eye, I have drawn some of the inner structure so you can get a sense of the mass and form underneath the surface of the eye.

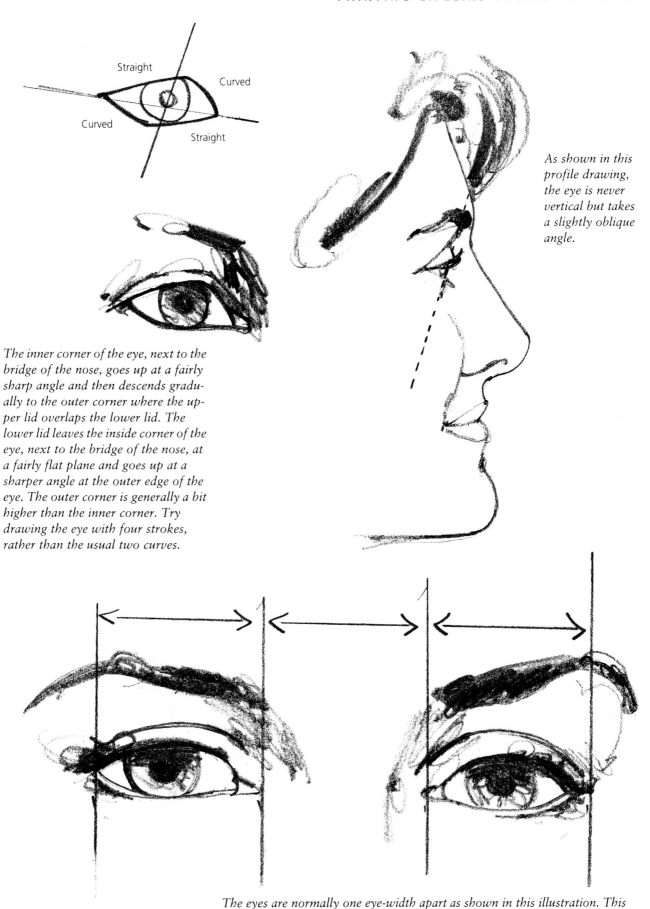

Straight

Curved

Curved

Straight

As shown in this profile drawing, the eye is never vertical but takes a slightly oblique angle.

The inner corner of the eye, next to the bridge of the nose, goes up at a fairly sharp angle and then descends gradually to the outer corner where the upper lid overlaps the lower lid. The lower lid leaves the inside corner of the eye, next to the bridge of the nose, at a fairly flat plane and goes up at a sharper angle at the outer edge of the eye. The outer corner is generally a bit higher than the inner corner. Try drawing the eye with four strokes, rather than the usual two curves.

The eyes are normally one eye-width apart as shown in this illustration. This can vary from person to person but is a good general rule to follow.

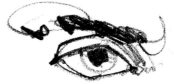

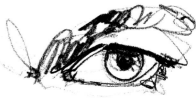

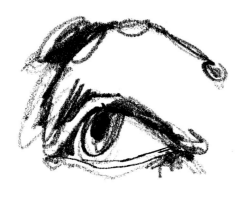

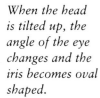

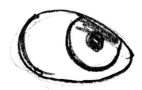

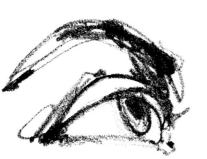

When the head is tilted up, the angle of the eye changes and the iris becomes oval shaped.

Pay attention to the iris and you will see that it is never fully exposed. Using the contour drawing technique, keep your pencil to the paper and begin drawing either eye starting with the iris as a round form. Proceed to draw the socket and the fold of skin (the lid) over the iris. With a lighter touch, draw the lower lid. Without lifting the pencil from the paper, return to the inner corner of the eye and move across the bridge of the nose to draw the other eye in the same fashion. The contour drawing method will allow you to draw the shapes of what you see rather than the separate parts.

In this three-quarter view, the opening between the lids becomes oval shaped because of foreshortening. Be sure to draw the lids so they go around the far side of each eyeball.

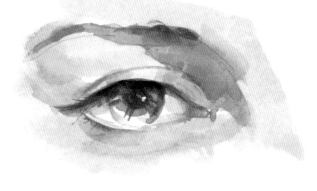

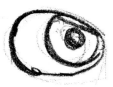

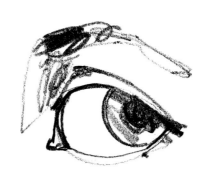

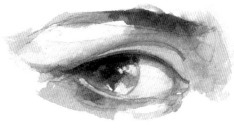

I have softened the edges of the eye in order to meld it into the face. The inside corner of the eye is softened into the cavity of the bridge of the nose while the outside corner has more clarity. I achieved this by bringing the brush down into the area I wanted softened.

The Nose

How I hated to draw noses when I was a student. It was just plain hard work and they didn't seem that important to me. I've learned their importance over the years, and I now try to capture them correctly. The upper half of the nose is bone while the lower half, including the nostrils, is cartilage. The nose stands out from the face, forming four planes or surfaces. Three of these surfaces—the front, and left and right sides—are wide and thick at the bottom and thin and narrow at the top. These three surfaces are joined by the fourth surface, another wedge-shaped form, which is the bottom of the nose. This bottom wedge can slant either up or down depending on whether the shape of the nose is pug or hooked. If you think of the nose in this way, you will find yourself drawing and painting much better noses. Ignoring the particulars at first and seeing the nose as flat planes can help you create the illusion of the nose coming out of the face, giving the feeling of depth. It is easy to depict the nose from a profile, showing it projecting from the face, but the tendency is to make the nose appear flat against the face in any other view. You must guard against this.

In these sketches I have shown the construction of the nose using the four planes that make up a nose. I have added a small triangular wedge at the top for the bridge to the forehead. Beside each of these I have drawn the nose more realistically. The first sketch shows the nose in a frontal view, the second as if the head were tipped back, and the third as if the head were tipped down.

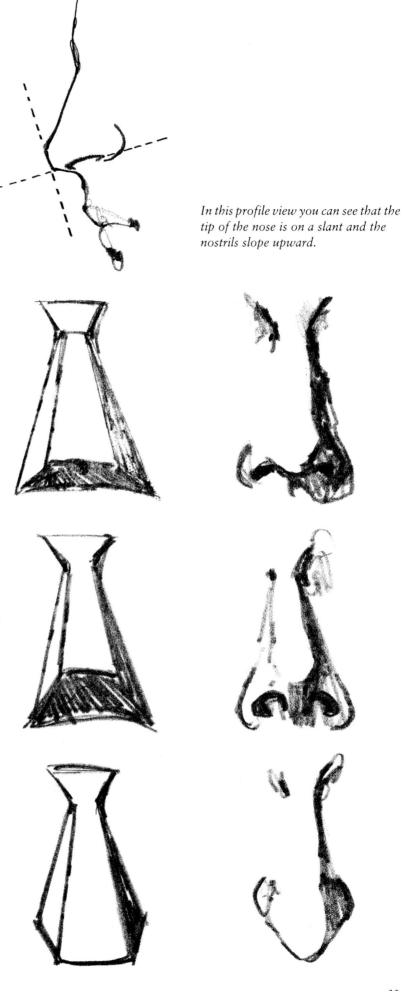

In this profile view you can see that the tip of the nose is on a slant and the nostrils slope upward.

The Ear

The ears are the most likely feature on the head to be ignored. They are set away from the face, have no movement, do not reflect much of the personality of the person and are often hidden by hair. But when the ear *does* show, your drawing abilities are tested.

Properly placing the ears on the head is most important. The top of the ear should be in line with the top of the eyebrow, and the bottom of the ear should be in line with the bottom of the nose. In profile, the upper front of the ear is on a line halfway between the bridge of the nose and the back of the skull. From a frontal view, the ear sticks out more at the top and slants inward toward the lobe, close to the back of the upper jaw. The upper portions are made of cartilage, while the lobe area is soft and fleshy. Ears can vary greatly from person to person but unless your subject has unique ears, such as large or protruding ears, draw them close to the head.

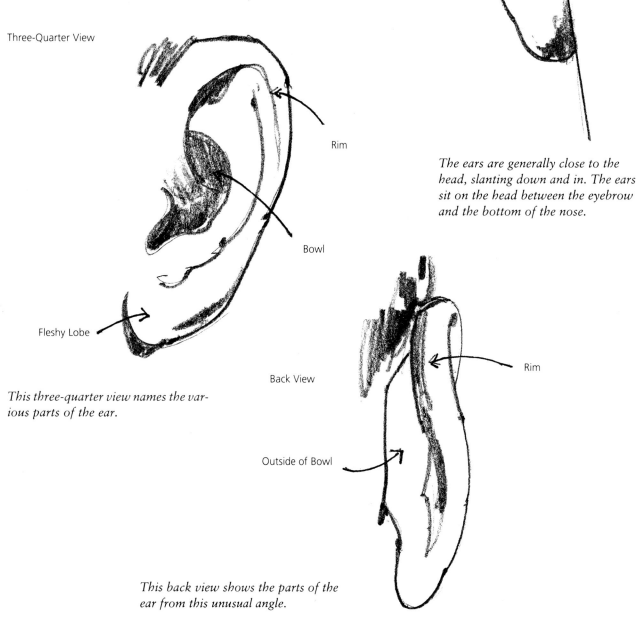

Three-Quarter View

Rim

Bowl

Fleshy Lobe

This three-quarter view names the various parts of the ear.

The ears are generally close to the head, slanting down and in. The ears sit on the head between the eyebrow and the bottom of the nose.

Back View

Rim

Outside of Bowl

This back view shows the parts of the ear from this unusual angle.

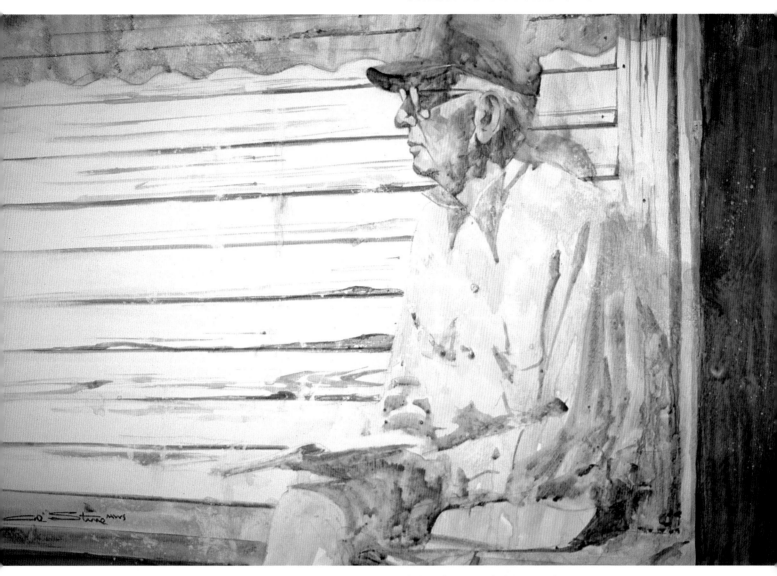

Mr. Wilson II (20″ × 28″)

Have you ever noticed that the ears of older people are usually larger than those of younger people? They develop a character of their own with lines, wrinkles and sagging lobes, which all add to the beauty of an older person's head. I much prefer painting an older person with all of the character that comes with age.

Painting Hair and Beards

When painting hair either on the head or face, soften the edges at the face so it doesn't appear as though it were cut out and pasted on like a bad hairpiece. When using a round brush, I lay the brush on its side and drag it along the length of the hair to get some interesting textures, keeping everything from looking too flat. I use a flat brush in the same manner, laying the brush on its side and dragging, sometimes even pushing it, to attain a desired texture. First draw and paint the planes or shapes of the hair as a whole, rather than each individual hair, leaving all detail work to be added later.

Softening the inside edges of the hair and beards creates the illusion of three-dimensional form. The viewer sees the round form of the head with areas such as the chin and nose coming forward, while other parts such as the ears seem to recede. In all of my paintings, I try to get a variety of rough, soft and hard edges for added interest and form.

Reference photograph of Rob, a friend of ours who happens to be a wonderful potter.

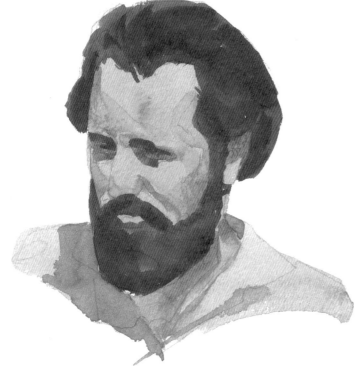

Wrong
This painting was done with hard edges around the hair. There was no softening of the hair or the beard into the face or background. You can see the "cut-out and pasted-on" look that resulted.

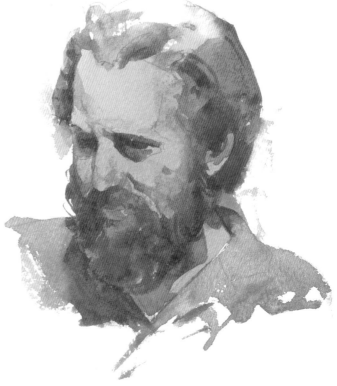

Right
In this painting, I softened the hair and beard into the face and background. I think you will agree this is a much better solution.

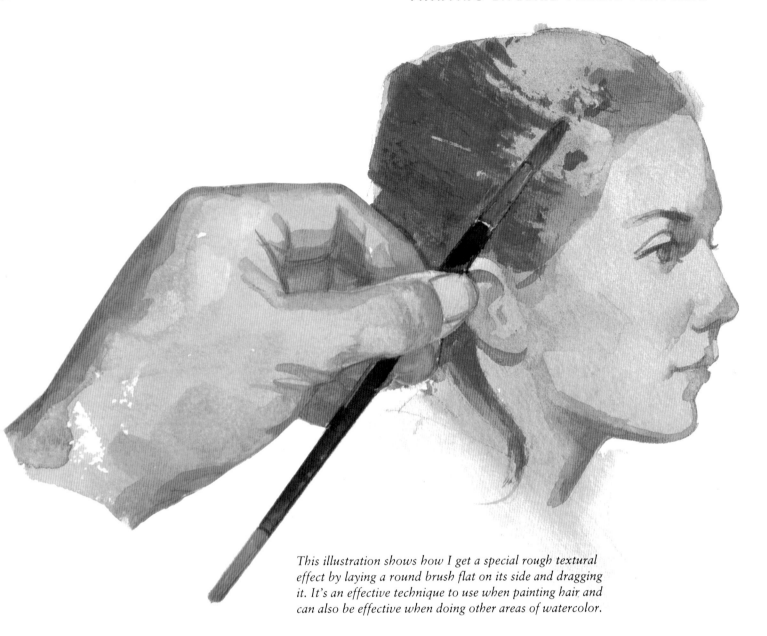

This illustration shows how I get a special rough textural effect by laying a round brush flat on its side and dragging it. It's an effective technique to use when painting hair and can also be effective when doing other areas of watercolor.

Placing the Features

Now that we have looked at the individual features of the head, we must learn to put them all together in their correct placement on the head. The observations I've given are only guidelines, a starting point, to help you depict the head.

Each person is different with features varying in size and shape. I can't stress enough that the best way to learn is to draw, draw, draw! Look at people, draw from the live model and see what makes humans so unique. Carry your

sketchbook and use it to make quick sketches when someone or something catches your eye. Join a group; if you can't find one, start a group that draws from a model. Practice and you will find your skills improving dramatically.

FRONT VIEW

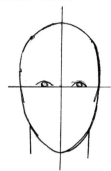
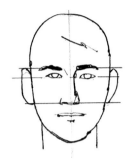
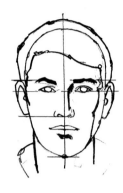

A.
Draw an oval for the head, then draw a vertical line down the middle and a horizontal line halfway between. The eyes are placed on the horizontal line one eye-width apart.

B.
Place the eyebrows just above the eyes, and the bottom of the nose halfway between eyebrows and bottom of chin. The mouth should be one-third the distance from the bottom of nose to the bottom of chin. The ears fall between the eyebrows and bottom of nose.

C.
Add hair and define the planes of the face. Note how hair grows over the skull, which differs from person to person.

D.
Erase all structure lines and add a light source to show form and shape for more solidity.

SIDE VIEW

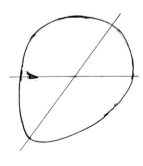
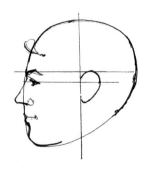
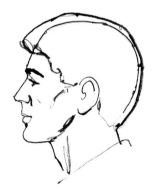
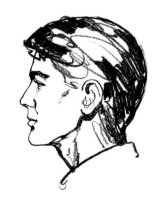

A.
Draw an oval on an oblique and widen it at the back. Draw a horizontal line halfway between the top and the bottom, placing the eyes just inside the front of the oval.

B.
Divide the shape in half. Place the front of the ear behind that line. The rest of the features should be placed exactly the same as in the front view.

C.
Define the features a bit more, as I have done here, by adding the jawline, neck and hair.

D.
Develop the form and shape of the head by showing the form as developed by a light source. Draw in the hair while still keeping the feeling of the skull beneath it.

THREE-QUARTER VIEW

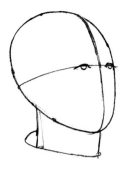
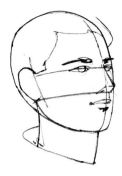
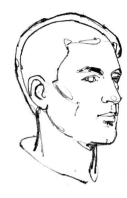

A.
In this modified egg shape, draw the vertical and horizontal lines so it appears that they go completely around the shape. Place the eyes on the horizontal line with the vertical line between them. Because it is farther away, the far eye must be drawn smaller, though not dramatically so.

B.
Continue placing the other features as explained in the previous views. The nose should project in front of the face, and the line in front of the ear will indicate the edge of the jaw line.

C.
Continue to develop the drawing by adding hair and defining the details.

D.
Develop the hair to show the shape of the skull, and provide a light source to bring out the shapes and planes. The light source creates the shadow on the right side of the face and under the jaw, which gives it solidity.

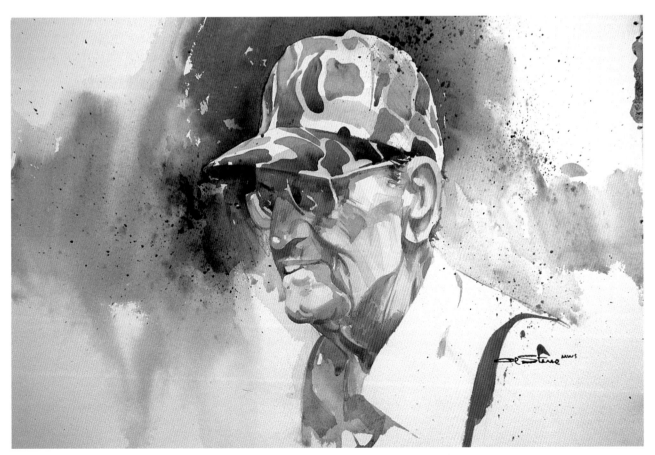

The Old Still Buster (15″ × 22″), in the collection of Pam Lamberson, Easley, South Carolina

This man's features are individualized, but their placement is still about the same as in the generalized diagram.

4 Mixing Beautiful Skin Colors

Most students are concerned with which colors to use when mixing skin colors. When I do a figure demo, someone will almost always ask, "What colors are you using to get that skin color?" Although color is important, color relationship, or the relationship of one value to another, is more important. But I went through the same process when I was a beginner, asking the same question. Therefore, I will give you some of the color combinations I have learned to use when painting skin tones. First let me share some principles I've learned about mixing colors in watercolor.

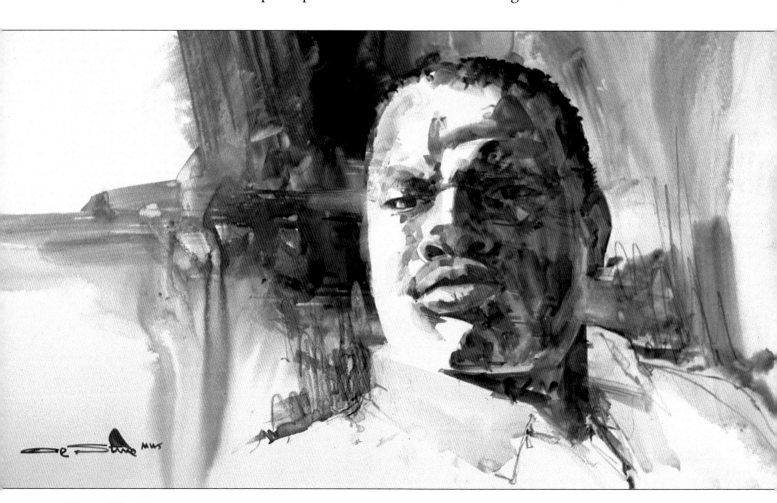

George (11″×21″)

My Colors for Painting People

The colors on my palette are constantly changing: It's fun to experiment and try new colors and methods. Here are the colors I am currently using, along with their qualities.

WINSOR GREEN

This is a cold staining green that is very intense and could easily dominate any mixture if too much is used. It is a lovely color for glazing. It's basically the same color as Thalo Green.

INDIGO

This is a dark blue black that I use in skies or to darken a mixture. I often use this color with Raw Umber or Brown Madder Alizarin.

COBALT BLUE

This is one of the workhorses on my palette. I use it when mixing skin tones and almost everything else. This is a great color when mixed with Raw Umber.

WINSOR BLUE

A cool staining blue, it has great tinting strength. It will dominate almost any mixture and should be used with prudence. I am often torn between using this color or Prussian Blue, which is close to being the same color with less of the staining qualities and, therefore, more easily lifted. It's basically the same color as Thalo Blue.

CERULEAN BLUE

A lovely blue, I often use it for skin colors and for backgrounds when mixed with a little Raw Sienna.

FRENCH ULTRAMARINE

This warm, dark blue is a little on the granular side, a quality I like in certain cases. It mixes well with other colors.

WINSOR VIOLET

Another cool, staining color. It thins out well and I use it primarily for graying any of the yellows, which make lovely grays. It also is nice when mixed with blues.

ALIZARIN CRIMSON

This is a cold staining red, a lively color that I use a lot. Wilcox says we should eliminate this color from our palettes because of its fugitive quality, but I have had no ill effects and continue to use it.

CADMIUM RED

A warm red with yellow in it, this color is very intense and is semi-opaque, so be careful when mixing it with other colors. Remember: Use only one opaque color in any transparent wash.

PERMANENT ROSE

This is the color Wilcox recommends using instead of Alizarin Crimson. It is a lovely cool red that mixes well with all colors. It is very transparent, even more so than Alizarin Crimson.

ROSE MADDER GENUINE

This is one of my favorite colors. It mixes well with all colors and is very transparent.

CADMIUM YELLOW PALE

A semi-opaque color with good covering power when used full strength. I use it primarily for skin tones, especially for fair complexions and young children.

CADMIUM LEMON

A cool yellow that is semi-opaque. One of the cool yellows that has good covering power. Hansa Yellow would be a good substitute and not as opaque.

AUREOLIN

This is a cool color that thins out well to make a very transparent color. I usually mix it with Rose Madder Genuine and Cobalt Blue, although it mixes well with almost any other color.

BURNT SIENNA

An earth color that is probably on everyone's palette. You can achieve a lovely gray by mixing it with Cobalt Blue or French Ultramarine.

RAW SIENNA

Another earth color, I often use this when mixing skin color, especially dark skin. It is fairly transparent and mixes well with other colors. It is more transparent than Yellow Ochre, which I do not keep on my palette but sometimes use in my skin tones.

RAW UMBER

I also consider this an earth color. It is darker and cooler than Raw Sienna and is another workhorse on my palette. I use it when doing darker skin mixtures and when I'm doing landscape painting.

BROWN MADDER ALIZARIN

A rich, warm dark with lots of power to darken a mixture. You can get this color by mixing Alizarin Crimson and Burnt Sienna.

IVORY BLACK

I sometimes use this color to gray other colors, such as Cobalt Blue. When thinned out, it makes a lovely silvery gray.

Avoiding Muddy Mixtures

In any painting, whether figures or landscapes, one of the things that makes it work is the beautiful foundation of grays the painting is built on. Most of the light and midtone colors should be neutral grays with more intense colors laid on top, making the painting sing. The grays are the building blocks that hold the painting together.

However, when we talk about grays, most artists become con-cerned about getting muddy passages in their paintings. Always keep a clean palette and clean water when painting people. You can get away with a dirty palette for landscapes, but not when painting skin tones.

PURE TRANSPARENT PIGMENTS

Pure pigments such as Rose Madder Genuine, Aureolin and Cobalt Blue are some of the most transparent colors available. You can intermix these colors and, if done properly, you will never get "mud." Lay a wash of Aureolin, then a wash of Cobalt over it, and a wash of Rose Madder Genuine over that. You can continue this process and make beautiful colors from a greenish gray to a purplish gray to a reddish gray to a brownish gray. You can, in fact, achieve just about any gray (warm or cool) that you desire. If these transparent colors start to appear muddy, you have succeeded in making a totally balanced mixture of the three. To "unmuddy" your mixture, simply add more of one of the colors.

The color bars on this page show three very transparent colors—Rose Madder Genuine, Aureolin and Cobalt Blue—and the wide range of grays you can get from them, running the gamut from warm to cool. When I seek transparent grays, they are my colors of choice.

> Lovely grays are best made with the more transparent colors. Semi-opaque colors will cause you to lose the beautiful transparent quality and will quickly turn to mud.

These panels were created by mixing the transparent colors of Rose Madder Genuine, Aureolin and Cobalt Blue, making lovely grays.

Mixing Good Darks
You can get beautiful, vibrant darks without being muddy. Here are two examples: On the left is a mixture of Alizarin Crimson and Winsor Blue; on the right is a mixture of Alizarin Crimson and Winsor Green. You can warm a dark by adding more red or cool it by adding either blue or green.

A Balanced Mixture
Here I mixed Rose Madder Genuine, Aureolin and Cobalt Blue. As you can see, the center appears muddy looking. This is because it is a balanced mixture. Since these colors are highly transparent, simply add more of one of the colors to unbalance the mix and you'll wind up with a lovely gray.

SEMI-OPAQUE COLORS

I've talked about how easy it is to avoid mud using transparent colors. But in the example on this page, I used a mixture of two semi-opaque colors. As you can see, the mixture is really muddy. The more opaque quality of the colors does not allow light to penetrate through to the paper and reflect back to the viewer, which causes murkiness.

Semi-opaque colors include Cadmium Red, Cadmium Yellow, Cadmium Orange, Cerulean Blue, French Ultramarine and others. These semi-opaque colors are indispensable in painting, but try not to mix more than one in any one mixture. If you do, you will get a heavy, dull, thick look since light cannot penetrate the color to the paper. When you get mud in this way, it is harder to remedy. You can try washing or lifting it off and starting over. Or you can follow this adage of questionable source: "The best way to make a muddy passage look less muddy is to paint a muddier passage within the muddy part." This works to some degree, but I try not to make muddy passages in the first place.

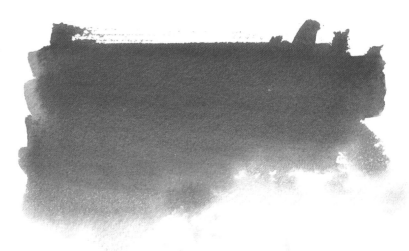

True Mud
In this mixture, I used Cadmium Red and Cerulean Blue, both of which are semi-opaque colors. The result is true mud. Although adding more of one color would help to unbalance it, the result would still be rather muddy.

STAINING COLORS FOR DARKS

Staining colors include Winsor Blue, Winsor Green and Alizarin Crimson. These staining colors are intense and powerful; a little goes a long way. I have had students say they never use Winsor Green because it is such a terrible color. Yet they soon change their minds when I show them how to modify it with another color or use it as a thin glaze. You can get beautiful darks with staining colors because they are intense while remaining transparent. Try mixing Alizarin Crimson and Winsor Green and see what a lovely dark you get. You can warm the dark by adding more Alizarin Crimson or cool it by adding more Winsor Green. The dark color can be modified with some Burnt Umber or French Ultramarine, but remember not to add more than one opaque in any given mixture.

Skin Tones

Skin tones are basically made by mixing red and yellow along with one of the compliments such as blue, green or violet. Although I do some mixing on the palette, I generally try to mix the colors on the paper so I can see them blend while maintaining control. Sometimes it looks as if I am mixing colors together on my palette and I will hear a student say, "Aha, caught you." But I have simply picked up more than one color on my brush. Picking up color in this fashion—one color on one side of the brush and a second color on the other side—and then placing the brush to the paper allows for a mingling of color while still being able to see the individual colors.

DON'T BE SHY ABOUT COLOR

Be careful not to get the colors too pale. When you place the colors on the paper, they might look intense enough but the color dries about 20 percent lighter. If you have to go over it with additional color, it is easy to cause mud. And if you don't go back over the pale color, it will look chalky and washed out when you lay your other colors around the area.

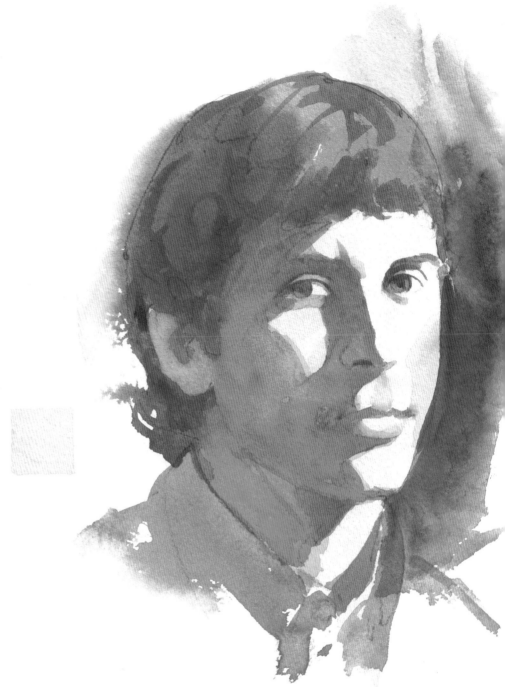

Wrong
Here the first wash is too pale, too weak in intensity. The color in the square is the same as the first wash of this painting. Although it looks intense enough by itself, you can easily see how chalky and washed out it becomes when the midtones and darks are applied over it.

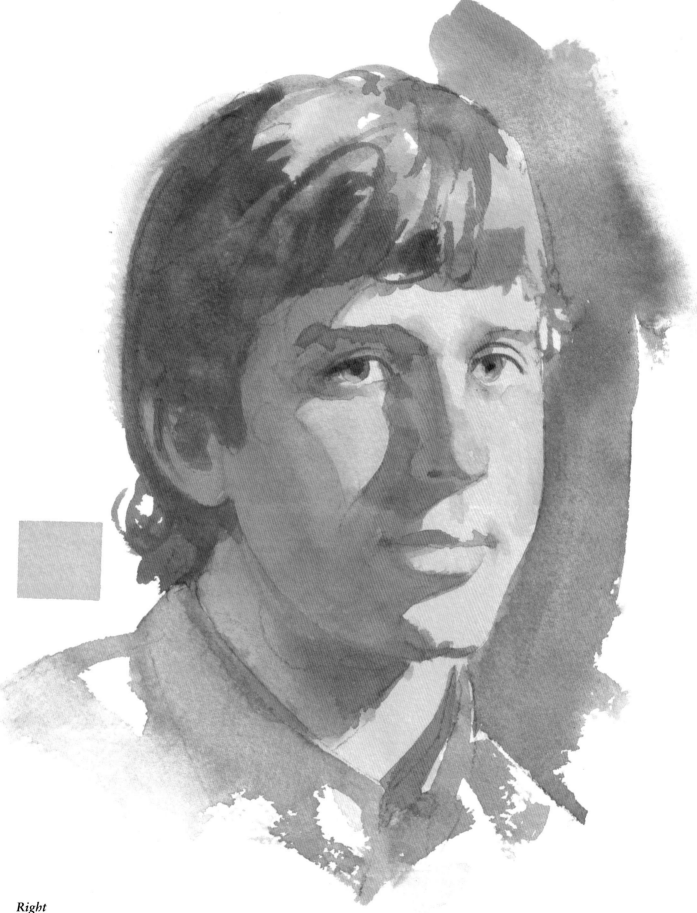

Right
Compare this color in the square to the one on the left, and you can see how much more intense the color is. As a result, when the midtones and darks are applied over the wash, the painting does not look as washed out as in the first example.

Fair Skin

When painting fair skin, I often use a basic mixture of Cadmium Red, Cadmium Yellow Pale and Cobalt Blue. Right away I'm contradicting my rule about not using more than one opaque in a mixture. It seems to work in this case when the value is kept light. The addition of a blue into a skin tone adds to the beauty of the skin tone but takes a little practice to get accustomed to. Be careful not to let the blue mix with the yellow or you will get green (not a desirable color for skin) or a muddy-looking color.

I don't always use the same combination of colors. I sometimes use Raw Sienna instead of Cadmium Yellow Pale or substitute Alizarin Crimson for the Cadmium Red. Much of this depends on the coloring of the subject and the lighting. These darker substitutions help achieve darker shadow areas without getting too heavy and opaque looking.

Here is the triad of Cadmium Red, Cadmium Yellow Pale and Cobalt Blue. I placed the colors on the paper quite juicy and, with a little coaxing from my brush, allowed them to mix together themselves. Varying percentages of mixture will be used for light, midtone and shadow. The color I chose for the basic flesh tone, used as the first wash, is found inside the square. Notice the slight separation of the red and yellow.

Step 1
The base color is a mixture of Cadmium Red and Cadmium Yellow Pale, creating a light complexion. I mixed the colors on the paper, allowing them to blend themselves. Notice how I painted outside the lines to soften some of the edges.

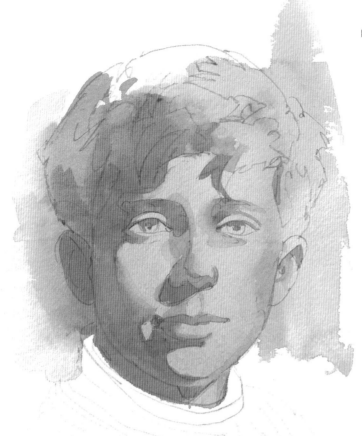

Step 2
I used Cadmium Red and substituted Raw Sienna for the Cadmium Yellow Pale in order to get darker values for defining the shadow areas. I softened some of the edges, but be careful not to soften too many edges or you'll wind up with something resembling a rubber ball.

Step 3
The darkest darks were made with Cadmium Red, Raw Sienna and Cobalt Blue. They were added only after the other washes had completely dried, and once again I softened some of the edges. This three-wash method is a fairly safe way of painting the head. The first wash is very flat. All the modeling is completed in the last two steps, done on top of the flat washes.

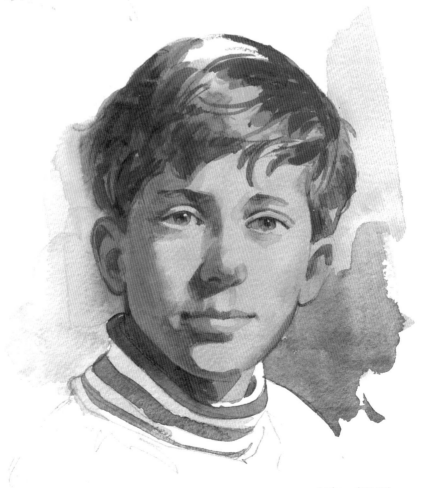

Anthony (6" × 8")

Another Fair Skin Palette

Another triad I use when painting fair skin is that of Rose Madder Genuine, Aureolin and Cobalt or Cerulean Blue. These very transparent colors will give you beautiful fair skin tones. When used with more intensity, you can also use these three colors to paint darker skin tones.

To achieve the basic skin tone indicated within the square, I used one of my favorite palettes of Rose Madder Genuine, Aureolin and Cobalt Blue. Because I wanted the skin tone to be on the pinker side, I first laid in a wash of Rose Madder Genuine into which I placed some Aureolin. On the right side, I used Rose Madder Genuine and Cobalt Blue to get a cool violet for shadow areas of light to midtone values. A more intense mixture of these same colors was used for the dark shadow areas. Although I did not do so, Ivory Black could be used in a mixture like this to achieve a darker dark.

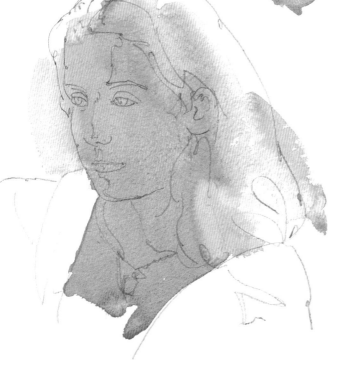

For this first flat wash, I used Rose Madder Genuine and Aureolin, allowing the colors to mix on the paper. As in the previous demonstration, I softened some edges so the color bled outside the pencil lines.

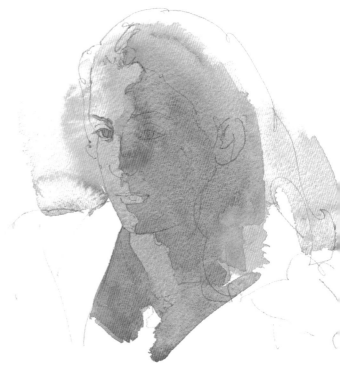

Using the same two colors, I applied the second wash of light to midtone values after the first wash had dried completely.

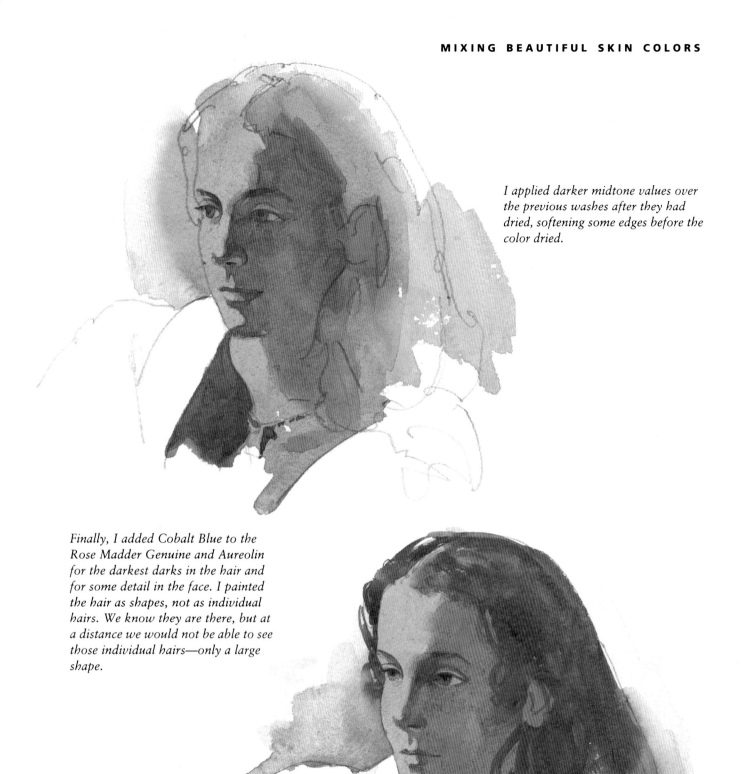

I applied darker midtone values over the previous washes after they had dried, softening some edges before the color dried.

Finally, I added Cobalt Blue to the Rose Madder Genuine and Aureolin for the darkest darks in the hair and for some detail in the face. I painted the hair as shapes, not as individual hairs. We know they are there, but at a distance we would not be able to see those individual hairs—only a large shape.

Skin Tones of a Different Color

You don't have to paint fair skin tones as "peaches and cream." Faces can be painted on the greenish or bluish side, so don't get boxed into thinking you must paint your skin tones to match those of the model. So much depends on the lighting and what is being reflected onto the skin.

Cobalt Blue, Rose Madder Genuine and Aureolin are used in the demonstrations on this and the next page. It's fun to play around with colors. Always remember, though, that color relationship is more important than the colors themselves.

Using a mixture of Rose Madder Genuine, Aureolin and Cobalt Blue, I intermixed the colors trying to get some different skin colors, something unusual. I have indicated the colors I used in these three demonstrations by enclosing them in squares (each of these are made up of all three of the colors mentioned above).

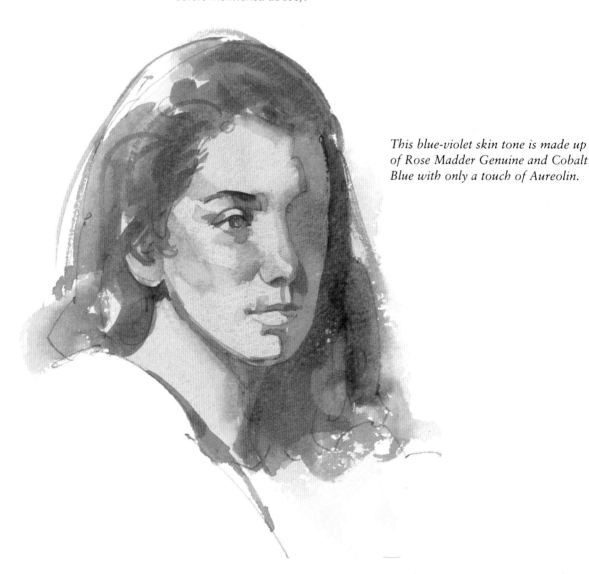

This blue-violet skin tone is made up of Rose Madder Genuine and Cobalt Blue with only a touch of Aureolin.

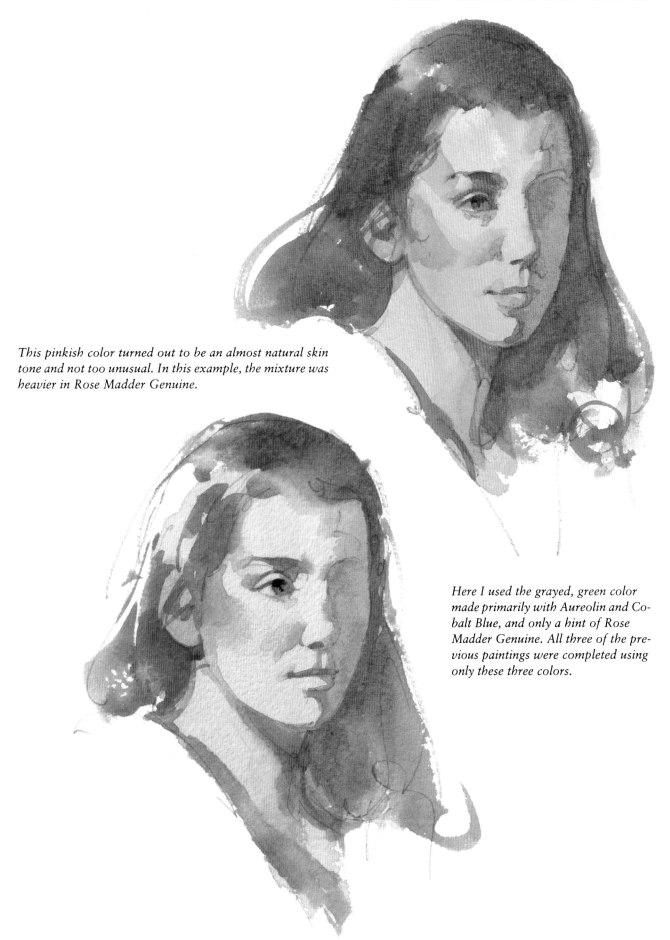

This pinkish color turned out to be an almost natural skin tone and not too unusual. In this example, the mixture was heavier in Rose Madder Genuine.

Here I used the grayed, green color made primarily with Aureolin and Cobalt Blue, and only a hint of Rose Madder Genuine. All three of the previous paintings were completed using only these three colors.

51

Mixing Color for Ruddy Complexions

A combination of Raw Sienna, Alizarin Crimson and Cobalt Blue will give you the ruddy complexion of someone who spends much of their time outdoors. Cadmium Red is a possible substitution for the Alizarin Crimson but since Cadmium Red is a more opaque color, it depends on what you are seeking in your painting.

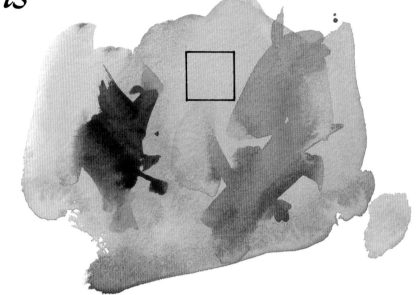

Using Raw Sienna, Alizarin Crimson and Cobalt Blue, I placed juicy colors on the paper and allowed them to bleed into one another. The midtone and dark values were made with the same three colors but with more intensity. I chose the tone I wanted for the basic skin color and indicated that by placing a square around it.

Step 1
I mixed Raw Sienna, Alizarin Crimson and a little Cobalt Blue in a very flat, juicy wash, letting the colors intermix on the paper. Be sure to go outside your pencil lines.

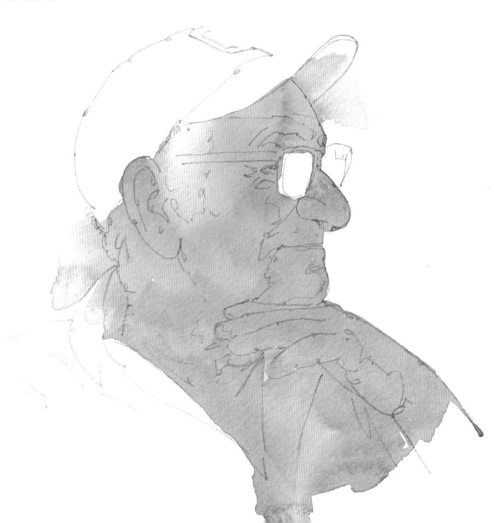

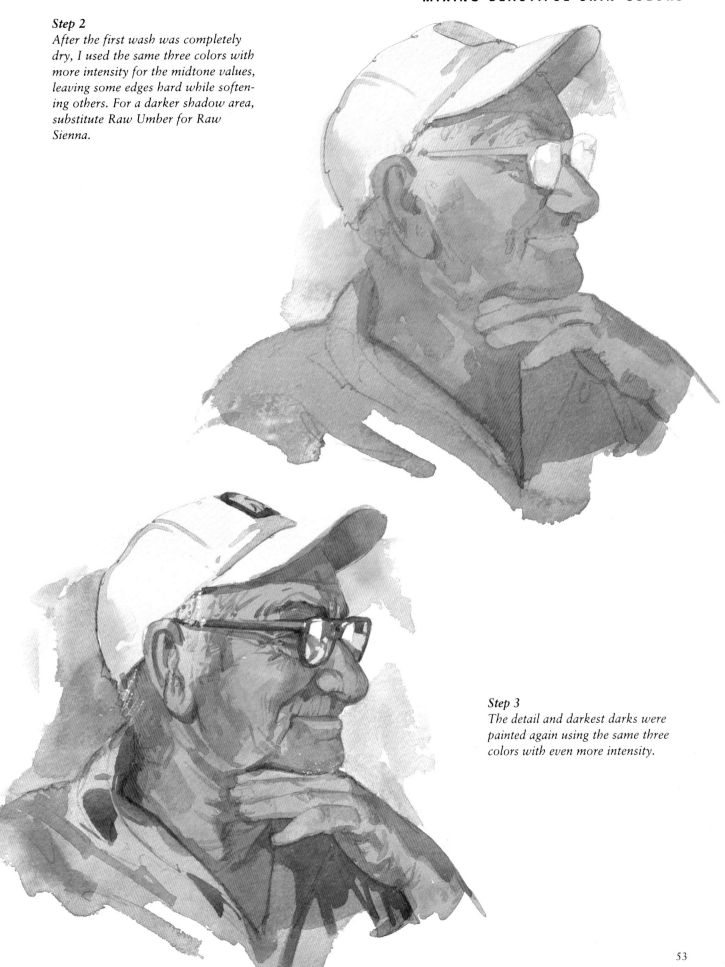

Step 2
After the first wash was completely dry, I used the same three colors with more intensity for the midtone values, leaving some edges hard while softening others. For a darker shadow area, substitute Raw Umber for Raw Sienna.

Step 3
The detail and darkest darks were painted again using the same three colors with even more intensity.

Brown or Black Skin

When mixing color to paint brown or black skin, I generally use Cadmium Red, Raw Sienna, Cobalt Blue, Hooker's Green Dark and Ivory Black. The Ivory Black is reserved for the hair along with some blue. I use very little of the Hooker's Green Dark. It's a great color to accent dark skin, but it is a staining color and is difficult to lift once you have put it down. Study your model and concentrate on the local color you can see, including the color that is reflected onto the model. This local color is more important than the shadows or the detail. I will sometimes substitute Alizarin Crimson for the Cadmium Red and Raw Umber for the Raw Sienna. These substitutions help to give it a darker value if needed.

One of the palettes I use in painting dark complexions consists of Cadmium Red, Raw Sienna, Hooker's Green Dark and either Cobalt or Cerulean Blue. Applying the colors very juicy, I let them intermingle on the paper. The basic color I chose for this painting below is indicated within the square.

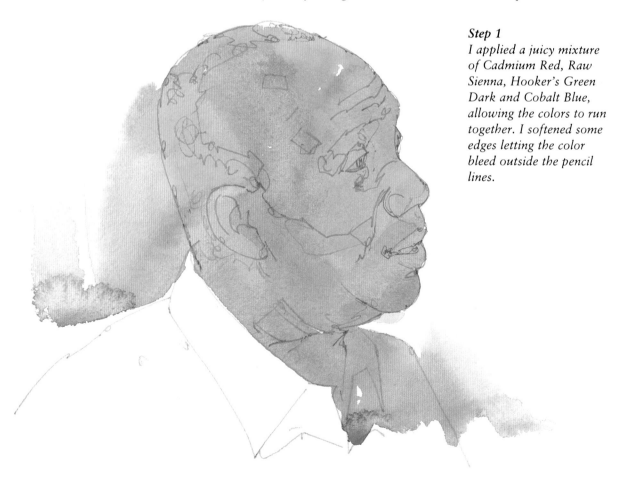

Step 1
I applied a juicy mixture of Cadmium Red, Raw Sienna, Hooker's Green Dark and Cobalt Blue, allowing the colors to run together. I softened some edges letting the color bleed outside the pencil lines.

Step 2
After the initial wash had dried, I added the midtones to model the form of the head, using the same three colors with more intensity and adding Hooker's Green Dark. Because of the model's skin color, I intentionally made these midtone values darker than usual.

Step 3
In this final step, I added the darkest shapes and detail using a more intense mixture of the same colors. Note that even though the hair is supposedly black, there is still a variation of color that remains transparent and not opaque looking.

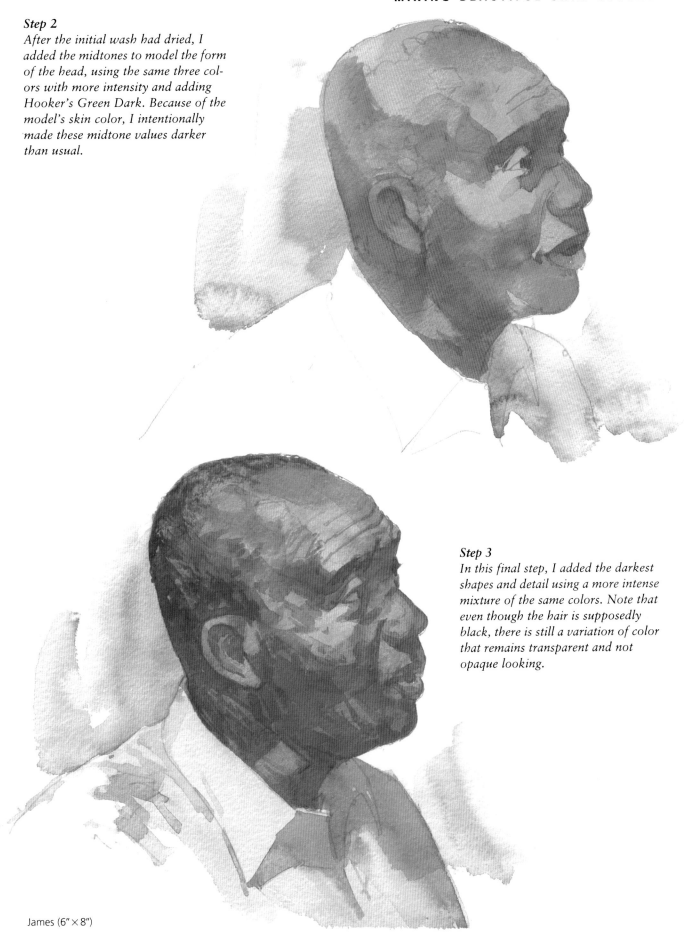

James (6" × 8")

5 Lighting the Pose

The light source is the most important factor when painting the head and figure, even more important than the pose. I prefer a single source of light rather than several confusing sources that leave you not knowing what to paint or how to paint it.

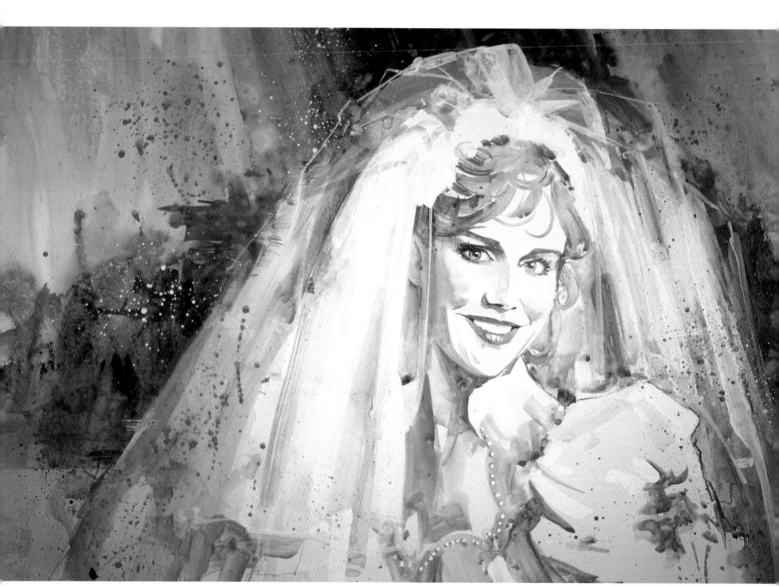

Cari (19" × 27"), in the collection of Mr. Richard Fox, Anderson, South Carolina

Many Lighting Possibilities

As you can see in the following photographs of my model, there are many possible lighting setups. However, some are just not suitable for painting the head. The more dramatic lighting setups, such as the Rembrandt lighting, are exciting and fun to paint because there is good separation of the lights and darks. If the light source is close to the model, the lights and darks are very pronounced. You cannot see much in the way of middle values nor can you see much detail in the darks unless you use a reflector. As the light source is moved farther away from the subject, you begin to acquire more of the middle values and more detail in the darkest values. This method also softens all of the values and is more flattering to the model.

I generally use a 150-watt flood lamp in a reflector on a stand so I can move it around with ease. If I need to see more detail in the shadow areas, I use a sheet of white board or paper to reflect some light back into the shadow area. Another method I use for picking up detail in the shadow area is to use a small fill light, usually a 60-watt bulb in a reflector on a stand, which allows me to place it exactly where I want it.

The more light there is on a subject, the lighter the values become on the lighted surfaces and the darker the values become as they turn away into full shadow. To fully describe the head or figure, you need three distinct areas of values. The lightest values indicate the light source, the middle values show the subtle modeling of the planes and hold the lightest and darkest passages together, and the darkest values show the underlying structure of the planes of the head.

But no matter what you paint, it is the *shapes* you should paint. With the proper lighting, you can more readily see those shapes. It is not the eye, nose or mouth that should be painted but the shapes that form them. If you can begin to think *shapes and values* rather than the separate parts, you will take a giant step forward in your painting.

This is a painting of Catherine "Cat" Marx, the model for all of the head shots in this chapter. The light source was at about ten o'clock and from the right—not quite Rembrandt lighting, but still pleasing and flattering to the model, showing off the eyes and nicely defining the nose.

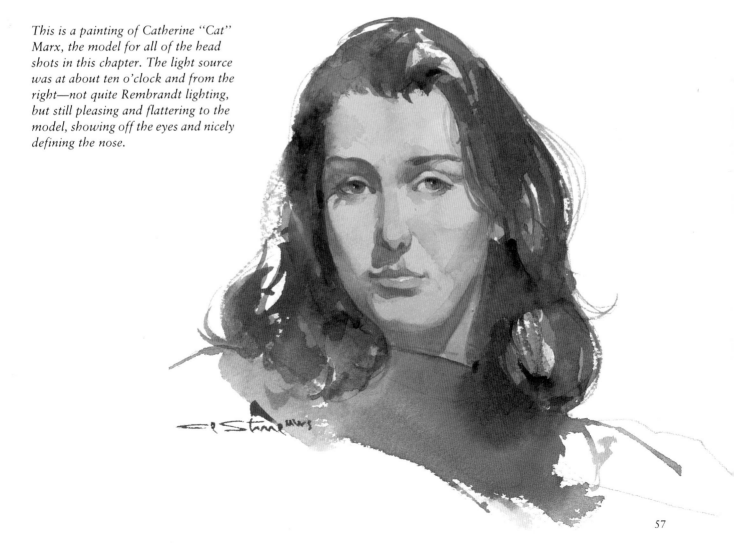

Lighting the Head—Side View

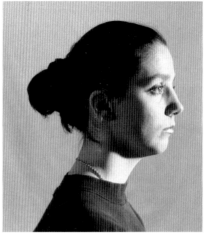

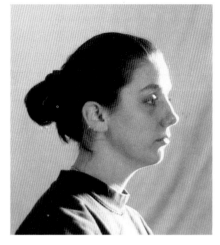

Frontal Light
The light was placed directly in front of and at the approximate level of the model's head. This can be good lighting for a painting as it brings out and emphasizes the form of the head.

Frontal and Above Light
This lighting is similar to frontal lighting except the light was raised to about ten o'clock. This lighting is more dramatic because it causes more interesting shadows.

Rim Light
The light was placed almost level with the head but off to the side, causing a rim of light on the front of the face. This gives an interesting effect to paint, but it is rarely used when doing a portrait.

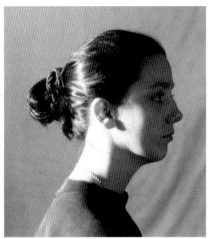

Back Rim Light
The light was once again placed level with the head but from behind. This is an interesting effect to paint, and while seldom used for a portrait, it is good for groupings of figures.

This sketch, drawn with the brush, had its light source from the back of the head and up slightly.

Lighting the Head—Front View

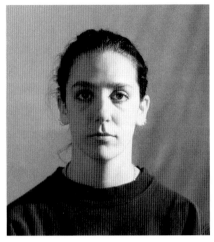

Side Light
For this setup, the light was placed level with the head and to the side. This dramatic lighting can be fun for the artist to paint although it is not often used for portrait work.

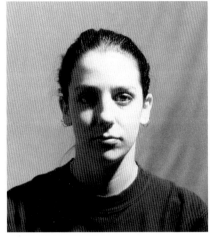

Rembrandt Lighting
You need only to see the name to know this method of lighting has been used for many years. The light source was set at about ten o'clock and to the front and side of the model. You move the light around until you achieve that little triangle of light that appears on the cheek away from the light source.

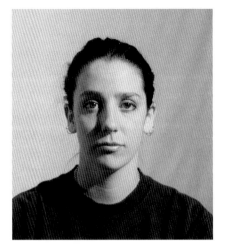

Rembrandt Lighting With a Reflector
The light source is the same as in the previous example, except I used a sheet of white paper to reflect some light back into the shadow side of the face. By doing this, I can see more detail in the shadow area while still having the strong lighting effect I want.

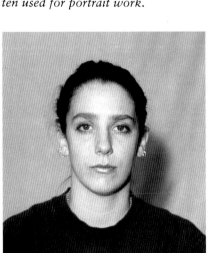

Frontal Lighting
The light source was placed in front of and just slightly above the model but a bit to one side. This is a good light source to use when painting the model since it is more flattering and eliminates wrinkles.

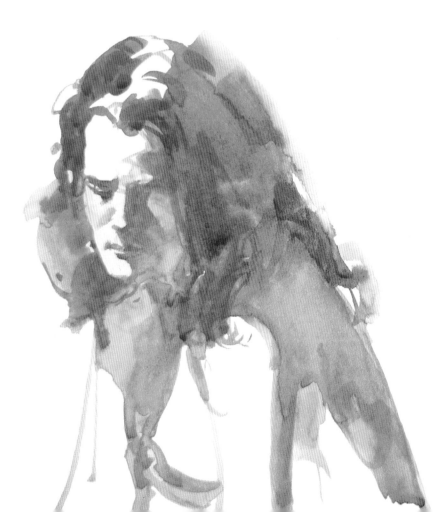

This drawing was done with the brush. The light source was at approximately ten o'clock and from the left.

Lighting the Head— Three-Quarter View

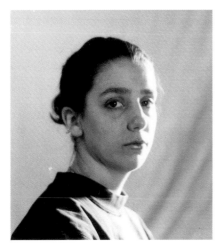

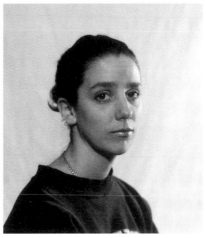

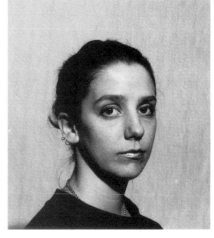

Side Light
In this three-quarter view, the light was placed directly to one side of the model and level with the head.

Rim Light
The light was placed to the side and behind the model to get the effect of a rim light.

Frontal Light
For this view, the light was placed directly in front of the model, slightly above the level of the head. This light source is flattering because it eliminates wrinkles and makes the model appear younger.

Rembrandt Lighting
The light source was placed very close to the model, which is dramatic and exciting for the artist but a bit too harsh for painting a portrait.

Rembrandt Lighting
This is the same light source as in the previous example except the light was moved farther away from the model. I still got dramatic and exciting lighting but without the harshness of the previous example.

Rembrandt Lighting
Again, the same lighting was used, moving it back even farther than in the last example. This is even more flattering to the model but more difficult for the artist since the plains on the head are not as pronounced. This is not nearly as much fun to paint.

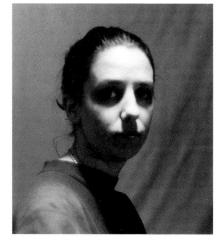

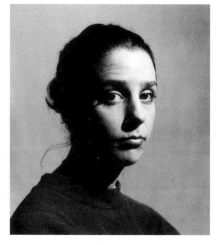

Bottom Light
The light was placed below the head, which can result in a somewhat ghoulish look. This would not make a pretty portrait.

Overhead Light
The light source was placed directly over the model, which creates deep, dark holes for the eyes. You would get the same effect if the sun was directly overhead, except the face would be bathed in reflected light and the shadows would not be as pronounced.

Rembrandt Lighting
I set up a photoflash placed to achieve Rembrandt lighting. I used a slave flash with a long cord to the camera. This system allows for a sharper image and more detail since the flash freezes all movement. To achieve even more detail in the shadow area, try using a reflector to bounce some light back onto the face.

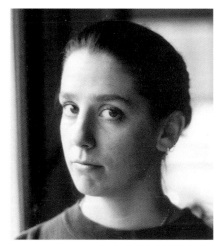

Natural Light
This is one of the loveliest light sources as it gives a very soft effect. I placed the model by a window and the natural light created a Rembrandt type of lighting. It's very flattering but a bit more difficult to paint because of the softness and the lack of sharp plane divisions.

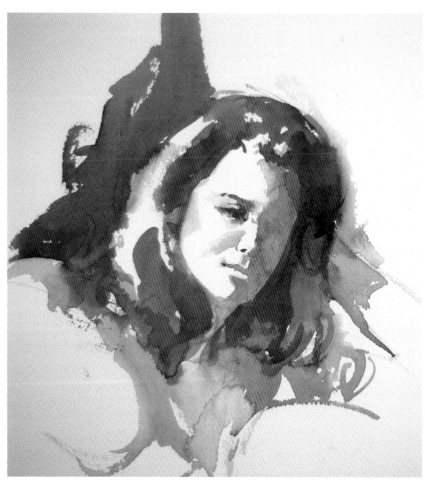

A strong light was placed above and to the left of the model. This sketch was drawn with a brush during sketch class.

Seeing Lights and Darks as Shapes

Many people in my workshops seem to have difficulty seeing and painting shapes. They have a problem defining the large masses of lights, middle tones and darks. Instead, they get bogged down trying to paint every little middle tone they see, resulting in an overworked painting. A general rule to follow is: Nothing in the lightest area of the painting should be as dark as the lightest darks of the shadows, and nothing in the shadows should be as light as the darkest values of the light areas.

A method that helps many of my students learn to see the large masses is to make black-and-white photocopies of their photographs, which they use as a reference for their paintings. I do this in both my landscape and figure classes. It simplifies values, turning them into abstract shapes.

This is an easy way to understand how to see and paint shapes rather than objects. Another advantage of using photocopies is that you can place a grid directly on the copy, avoiding damage to your original photo. You can grid the copy and then enlarge the grid to scale on your watercolor paper. This saves drawing time and keeps the paper much cleaner.

This painting was done at a South Carolina Watercolor Society workshop. The light source was the overall soft light that illuminated the room. There was no direct light source and, as a result, everything was flattened out.

USE PHOTOCOPIES TO CLARIFY FORM

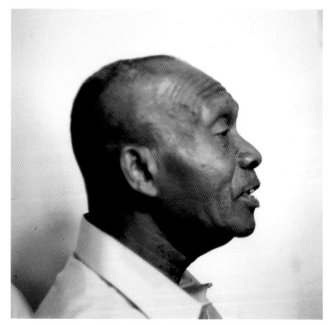

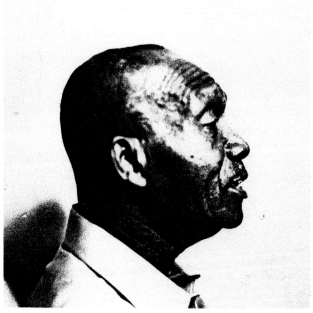

My model here was James Knox from Charleston, South Carolina. The light source was from the right and just above the head, creating fairly good patterns of lights and darks.

I placed my original, full-color photograph onto a copier to get this photocopy. This is great to use when painting to show the clear breakdown of lights and darks. I always refer to the original for the midtone values.

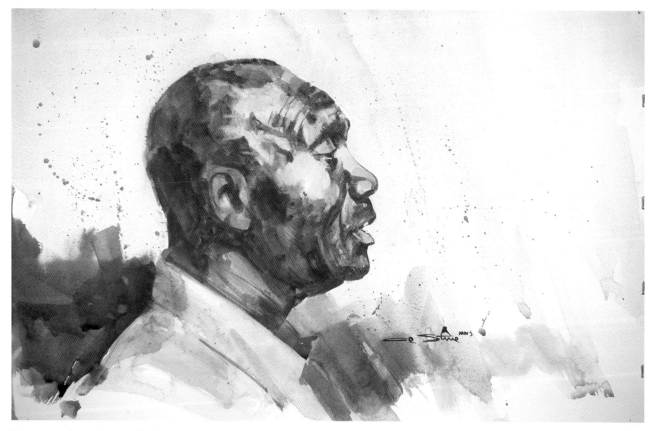

You can see in this finished painting that using the copy enabled me to capture the strong lights and darks. It also made it much easier to define the various planes and shapes of James's head.

Lighting a Figure

Side View
Cat let her hair down for these shots. I set the light directly in front of and just a little above her head, which created a very flattering light showing good planes. Note how her cheekbones are emphasized.

Three-Quarter View
I set the light source above and to the right, which is also flattering for the model. This source still gives good plane divisions and excellent darks and lights.

Front View
The light source was placed slightly to the right and above the model, creating a very strong light that brought out her features. This is a modified Rembrandt Lighting that leaves more of the face in the light, making it more flattering to the model and perhaps somewhat easier to paint.

Keeping Shadows Transparent

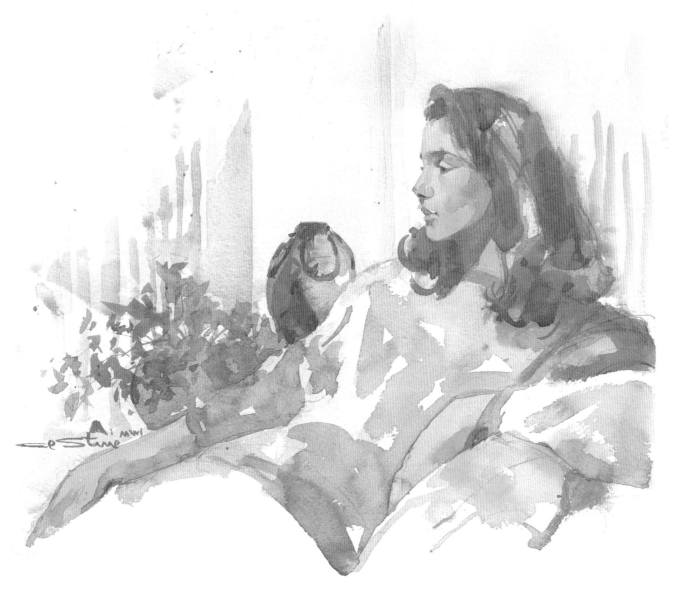

When working from either photographs or the live model, constantly be aware of the tendency to get the light and midtone values too dark, too early in the painting. If you are working from photographs, the camera seems to intensify the darks and the artist tends to paint the darks just as dark as they appear in the photograph. This can also be true when using a strong light source on a live model. The shadows will seem very dark, which indeed they are, but try not to paint them that way—rather keep them transparent. I once had an instructor who said, "Shadows, no matter how dark they seem to be, should be transparent so that you not only can see into them but feel you could walk into them." If those darks are opaque, it will be like walking into a brick wall and will stop the eye from looking into the depths.

If you get too dark right away with the lighter values, you will have nowhere to go with the darkest darks without having the painting become very heavy. If you have this tendency, it is better to keep your paintings in a higher key or begin with the light and midtone values, gradually building up to the darkest values.

The painting above was done from the side-view photograph at left. I made a conscious effort to keep the painting in a higher key, trying not to paint anything as dark as it appears in the photograph so that I could keep the shadows transparent.

6 Designing the Head and Figure Into a Painting

When I paint the head, I don't like to do much in the background that would distract from the head. I'm more concerned with spatial relationships and the relationship of all elements within the rectangle of my paper. When designing a painting using the figure, my design approach is similar. I generally do not like much going on in the background. There are exceptions such as the painting below. When I tell a story about the person in the painting, I set the stage, so to speak. But if I am doing a regular portrait, I want to show the head and figure to their best advantage; anything that distracts from that is better left out. I plan the placement of the figure in relation to the rectangle of the paper, just as I do when only painting the head.

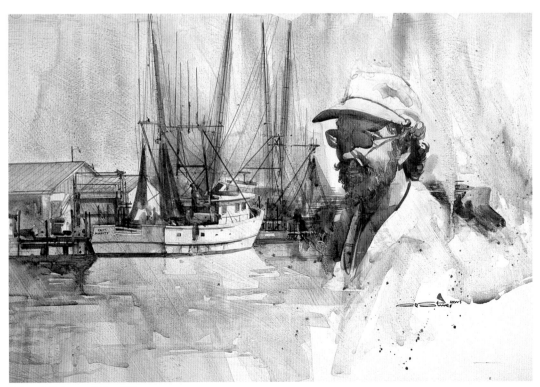

I have painted Michael several times. In this painting, I wanted to tell a story related to his occupation and took artistic license by placing him in a shrimp boat scene. He is really a lobster fisherman.

Oriental Shrimper (20" × 28")

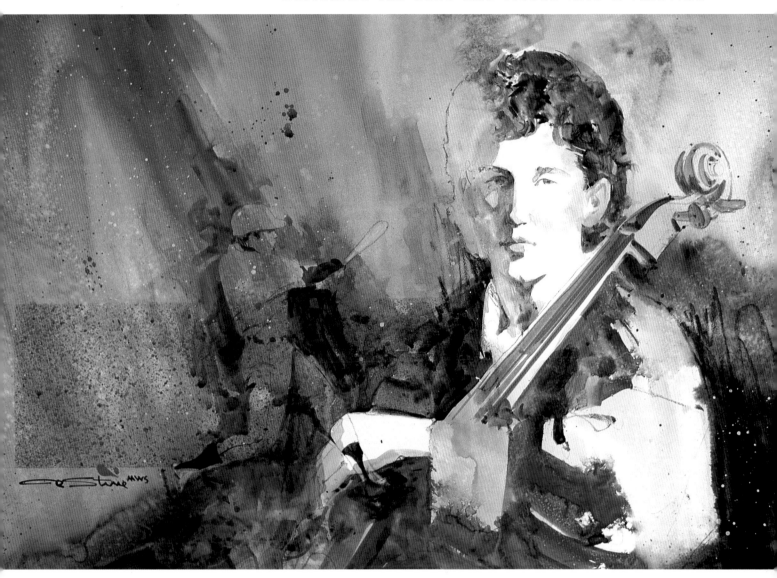

Daydreams (14″ × 20″)

Telling a Story

You can tell a story by using objects related to your subject's life as seen in the painting at left. Or you can set the stage for a standard figure painting but also tell a story without putting too much into the background. For example, look closely at the painting of the boy with the cello and you will see the figure of a baseball player in the background. My thought was that although he was practicing his cello, he would rather be playing ball with his friends. It's not obvious, but it is there. You may not agree with this approach and you might prefer more detail in your backgrounds. There is no one correct way to approach a painting; approaches are as varied as the artists themselves.

You can also tell the viewer much about your subject by the way you set the facial expression and general mood of your painting. Pay attention to the eyes and mouth. These features are very expressive and deserve your full attention.

Arranging Shapes

Let's have a little fun. Paint three different values with the colors of your choice on scrap paper. Cut each value into different sizes and shapes and play around, moving the pieces about on your paper. Place the pieces in different spatial relationships and see which one is most pleasing to your eye. Each person will come up with something different, but if you follow good design principles, each will look great. The same will be true in your paintings. Deliberately arrange the head, along with the background shapes, on the painted surface. Each shape has to be related to all of the other shapes in the rectangle. Remember to place light shapes against dark shapes and warm shapes against cool shapes.

If you are going to do a vignette, the four corners of the rectangle should each be a different shape and size. Leave white in the subject matter to balance the white left in the corners of the vignette. As you can see from the examples on this page, it is important to get the spacial relationships right so that you achieve a pleasing design. Without a good design, even the best drawing won't add up to a successful painting.

I arranged these cutout shapes into a perfectly balanced design that is boring because it is so static.

This is also a boring division of space because each negative space is the same size and shape.

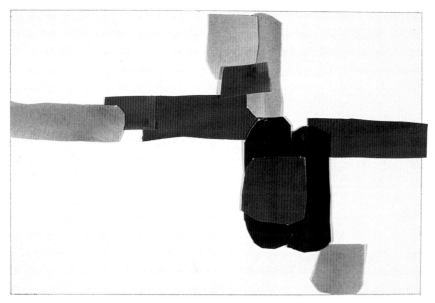

I arranged the various shapes into a more pleasing design by giving each negative shape a different size and shape. This idea is the basis for designing the head or figure into a painting.

Placing the Center of Interest

There are many ways of designing a painting. One way is to plan the light patterns to lead the eye into and then around the painting, making the viewer stop to look at what we want them to see. While this is a good way to design, it can get quite complicated. These illustrations show one fundamental method of finding a place to start the center of interest in a painting. Some people have a built-in sense of design but it does not come as easily for others, so use this system as a learning tool. After using this method for a while, you won't need to go through this routine every time. It will become intuitive.

To improve your understanding of what makes a pleasing design for painting a portrait, study artists such as Sargent and see how they place a subject within a rectangle. Take note that Sargent did not put a lot into the backgrounds that would distract from the head or figure.

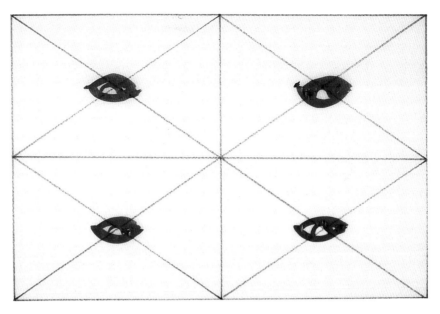

Divide Your Rectangle
Divide your rectangle into four other rectangles and then find the center of each of those rectangles with diagonals. The center of any one of these rectangles would be a good place to locate the center of interest and begin drawing the subject. Although this is a good way to locate the center of interest, you will soon become accustomed to "feeling" where it should be and not need to physically divide the rectangular shape of your paper.

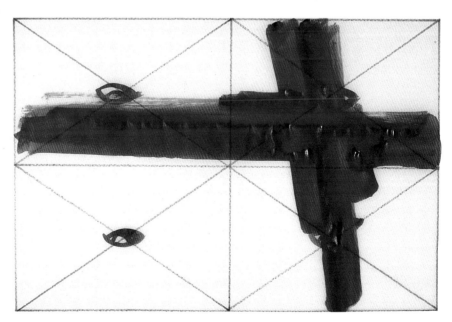

This is an example of how I might choose my center of interest, based on the cruciform design plan. The word cruciform defines itself: It is simply a takeoff on the cross. It does not have to be perfectly vertical or horizontal; either or both directions can be on an oblique. In this case, the vertical part of the cross is on an oblique while the horizontal is flat and level.

PORTRAIT USING THE CRUCIFORM DESIGN

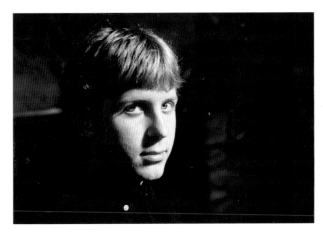

Photo
In taking this photograph of Cullen, I used a single light source that was set to his right at about ten o'clock.

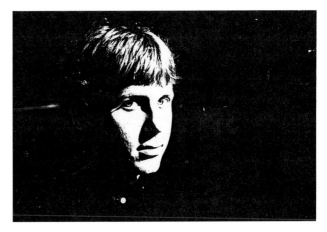

Value Shapes
This black-and-white photocopy of the photograph makes it easier to see the most important values and shapes.

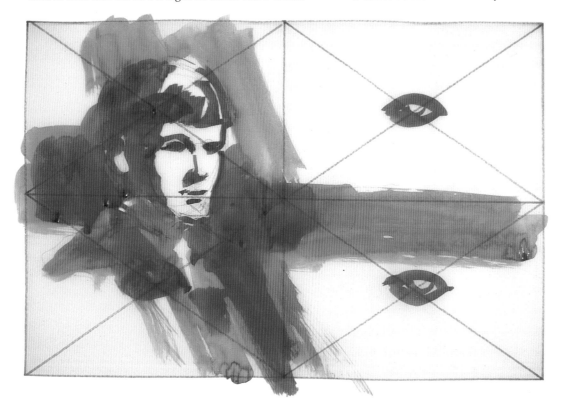

Design
In this layout sketch I have chosen the upper left section to place the head because my model is looking from the left into the painting. This design is basically a mirror image of the cruciform design in the example on the previous page.

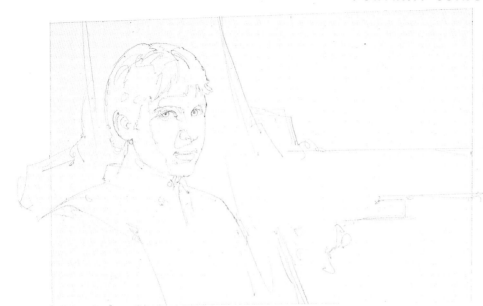

1 *I did this pencil drawing working from the photograph and the photocopy. I also penciled in the shapes I intended to paint in the background based on the earlier planning of the cruciform.*

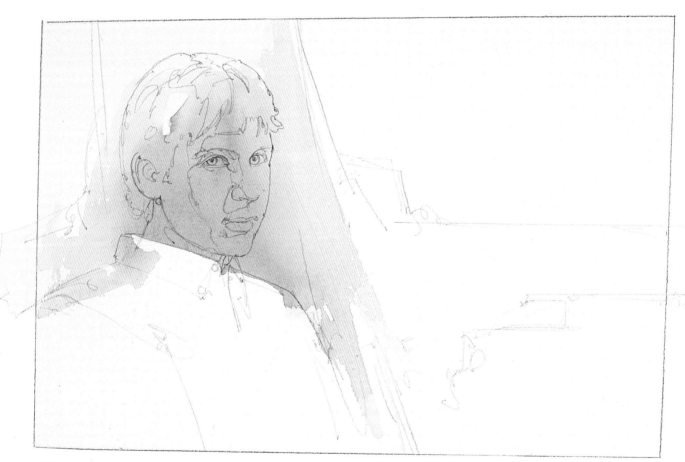

2 *For the skin color I used a mixture of Alizarin Crimson, Cadmium Red and Yellow Ochre. I did not mix these colors together on my palette but picked each up with my brush, allowing them to mingle and mix on the paper. You will notice I painted the color beyond the pencil lines and into the hair and background for a more natural effect. This keeps the head from looking cut out and pasted on. In some places you can see each color individually as they blend together. You must work really juicy to accomplish this.*

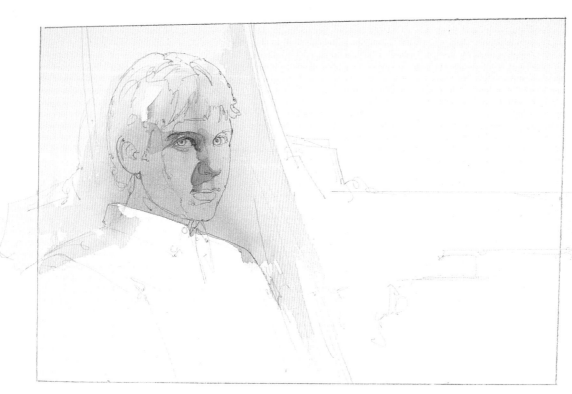

3 *After allowing the paper to dry completely, I began this next step using the same colors but with more intensity. Being very careful with the drawing, I started on the left eye, continuing down the nose to the shadow area under the nose. I left some hard edges but softened the edge of the nose's bridge and the edge over the upper lip with a clean, damp brush.*

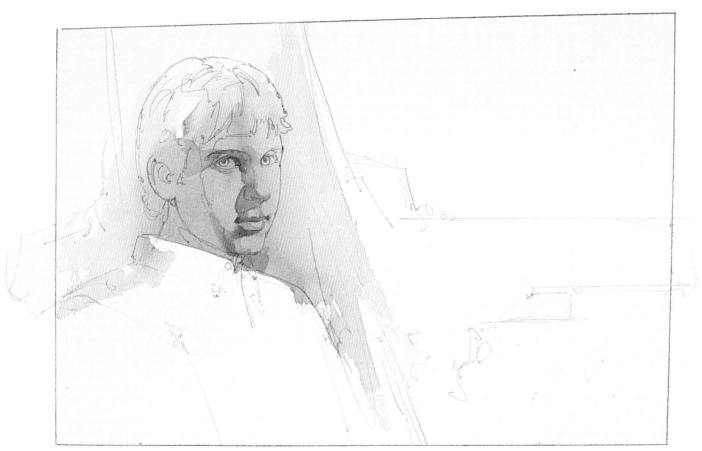

4 *I painted the lips, paying careful attention to the shapes I saw in the photocopy. I softened the color of the upper lip toward the shadow under the nose.*

5 *In this step I painted the large shadow shape on the left side of the face, carrying the color up into the hair and out into the background. While this wash was still wet, I softened the cheek into the rest of the face.*

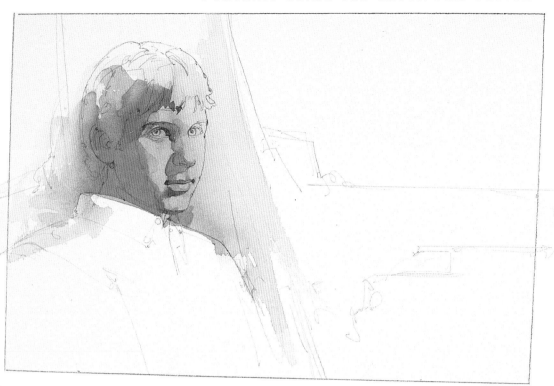

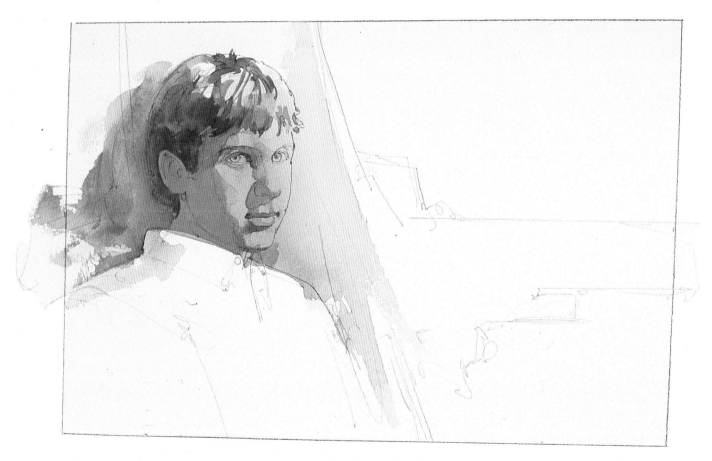

6 *Since I was developing a vignette with the cruciform design plan, leaving some white in each corner, I wanted to be certain to leave some of the white of the paper in the head and shirt. I then painted some of the more important shapes I saw in the hair using Yellow Ochre and Raw Umber, grayed with a little Ivory Black. While wet, I softened this color into the background on the left.*

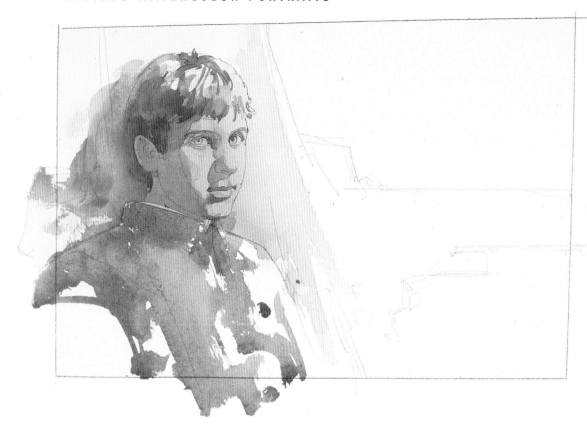

7 I painted the right eye, being careful not to get too deep a value since the eye is in the light. At this time I also painted the shirt with a mixture of Cobalt Blue and Alizarin Crimson, leaving some whites to tie in with the whites of the vignette.

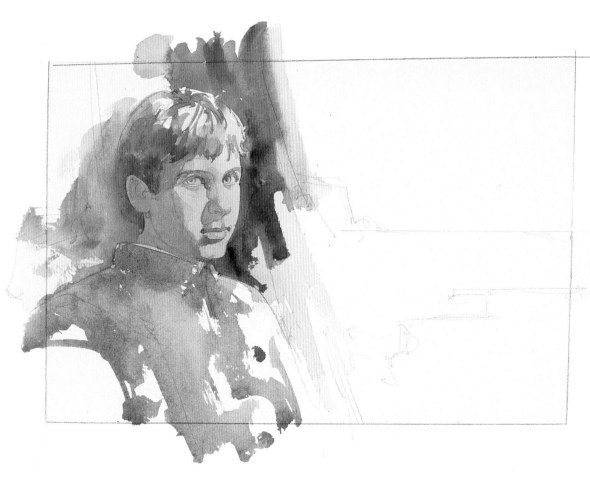

8 I painted a dark value in the background, softening some edges at the hair and outer edges of the background. I kept a hard edge along the right side of the face.

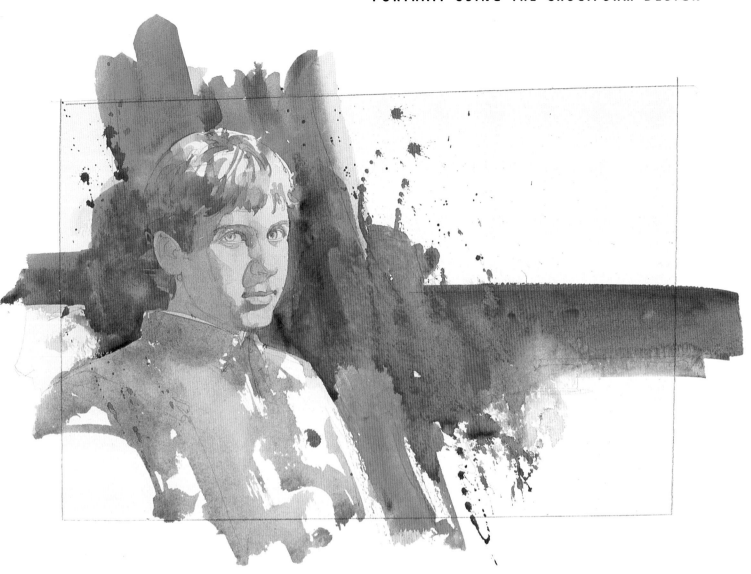

9 Continuing with the background, I painted the remaining major shapes trying to retain a variety of hard, rough and soft edges. I sprayed the lower right with clear water to achieve some soft edges and a little different texture, then allowed the painting to dry completely.

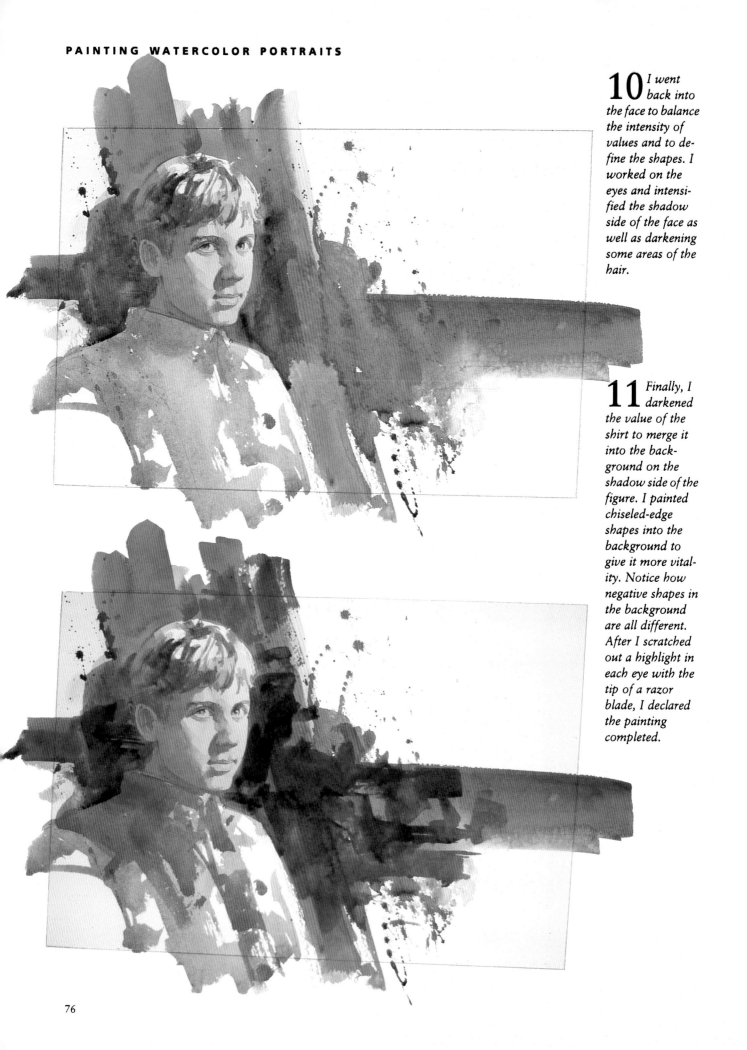

10 I went back into the face to balance the intensity of values and to define the shapes. I worked on the eyes and intensified the shadow side of the face as well as darkening some areas of the hair.

11 Finally, I darkened the value of the shirt to merge it into the background on the shadow side of the figure. I painted chiseled-edge shapes into the background to give it more vitality. Notice how negative shapes in the background are all different. After I scratched out a highlight in each eye with the tip of a razor blade, I declared the painting completed.

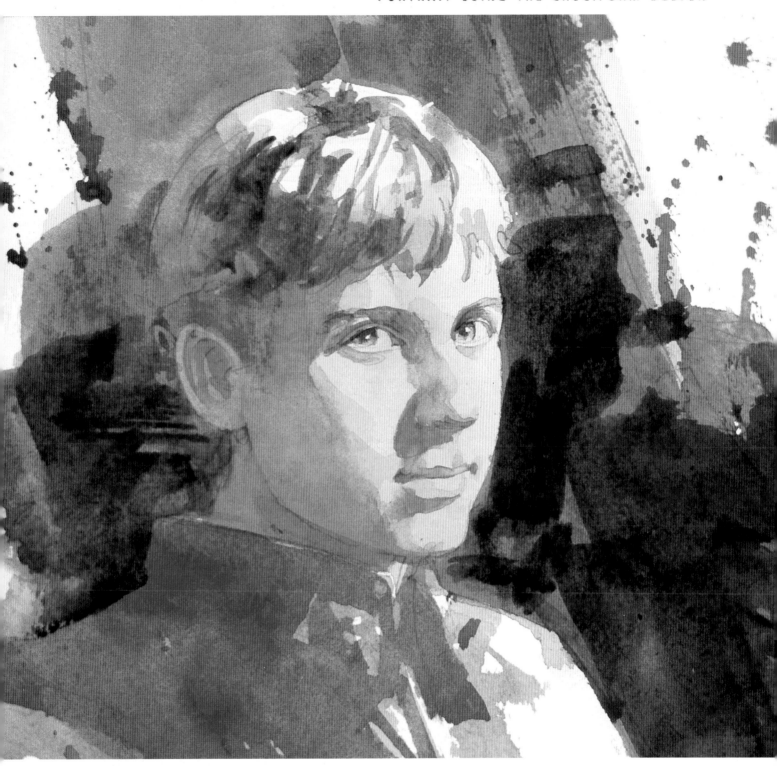

Detail of finished head.

PLANNING WITH THUMBNAIL SKETCHES

Taking the time to plan your painting is a major step toward success. First, work out your design in a series of small thumbnail sketches. Do as many as you need to until you are satisfied that you've developed a great design. Next, do a detailed drawing based on the thumbnail, your photo and the black-and-white photocopy, if you have one. Simplify your drawing, using tracing paper to reduce it to simple shapes. Then transfer the simplified drawing to your watercolor paper.

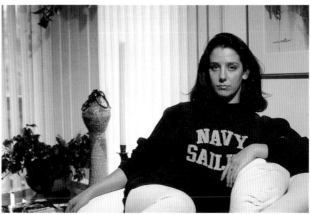

I used this photo of Catherine to do the three thumbnail drawings.

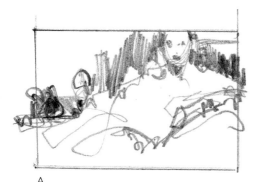

A

B

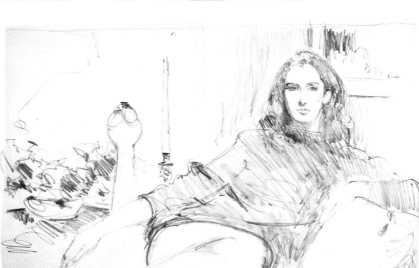

Tracing Paper Drawing
I did this drawing using the photograph and thumbnail "C." I like drawing on tracing paper because the pencil glides over the surface effortlessly, it's easy to erase with a kneaded eraser, and by doing the initial work on tracing paper my watercolor paper does not get sullied with graphite. Although I used the photograph for reference, I made the head smaller and elongated the figure. This made it more visually appealing than if I had just traced the figure from the photo to my paper.

C

Thumbnail Sketches
A. The figure is high in the rectangle, which is not a good solution.
B. The figure is low in the rectangle, again not a good solution.
C. Here the figure is better positioned in the rectangle and is the reference I used for the following drawings and painting.

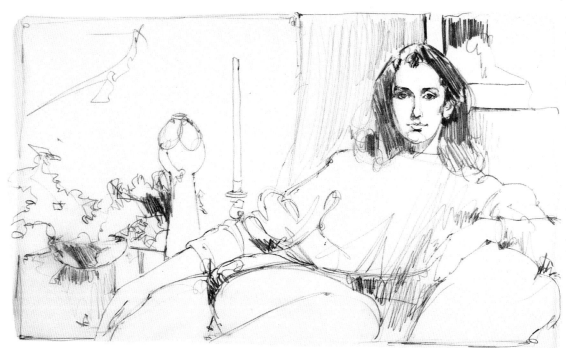

Refining the Drawing

Another reason I like using tracing paper is that I can lay a fresh sheet over a previous drawing, rework it and make any changes. I did just that with this drawing, simplifying while concentrating on getting better shapes. You can see there is not as much modeling as in the previous drawing.

1 I used carbon paper to transfer the second drawing onto my watercolor paper, reworking it somewhat using an HB pencil. My paper was Arches 140-lb. cold press.

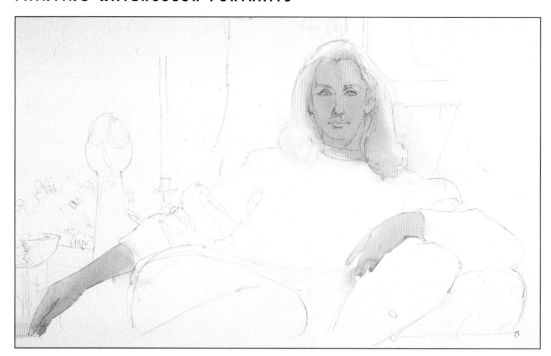

2 I laid a mixture of Yellow Ochre and Cadmium Red on the skin areas. Rather than totally mixing the colors on the palette, I let them mix on the paper. I let the colors travel outside the pencil lines to soften into the hair and background.

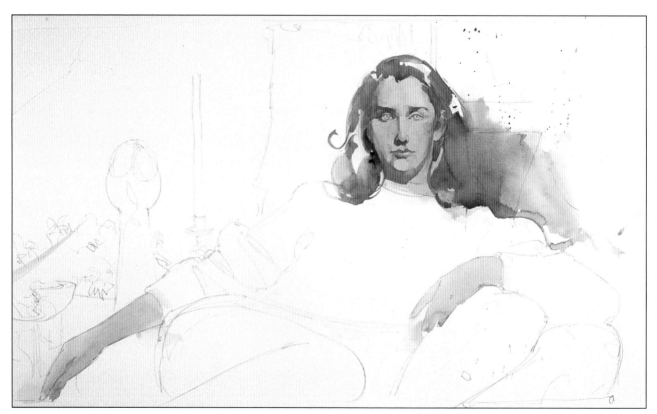

3 I slowed down at this point, carefully adding some modeling to the face using darker values of the same two colors. I then painted the hair, trying to capture the shapes I saw in the photograph, and softening the right side of her hair into the background.

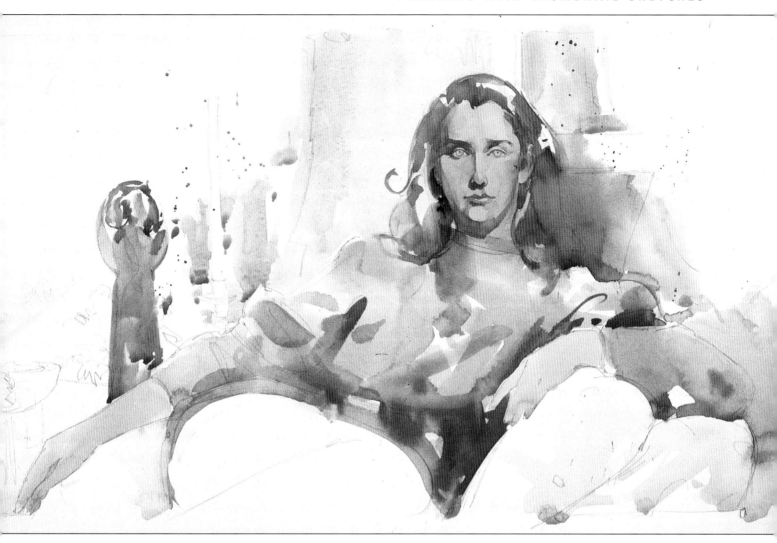

4 I chose to paint the blouse a violet color, intentionally staying away from the very dark color seen in the photograph. Notice how the values I previously painted on the face appear lighter now that there are other colors placed around it.

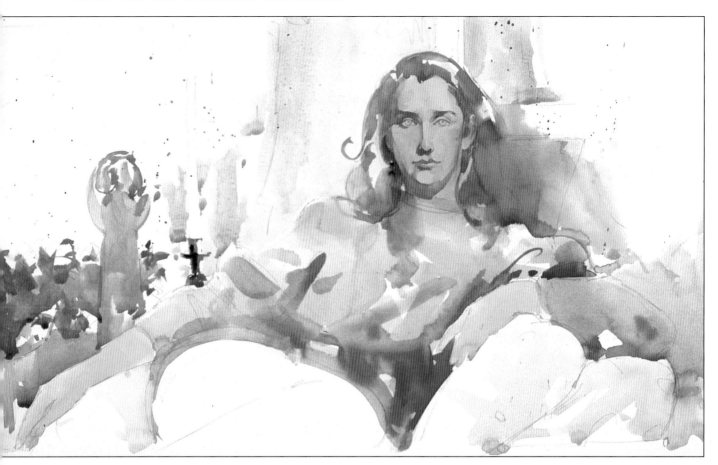

5 *I painted the table, chair and sculp-*
ture using some of the same colors
I used on the hair. I used a mixture of
grayed blue for the plant.

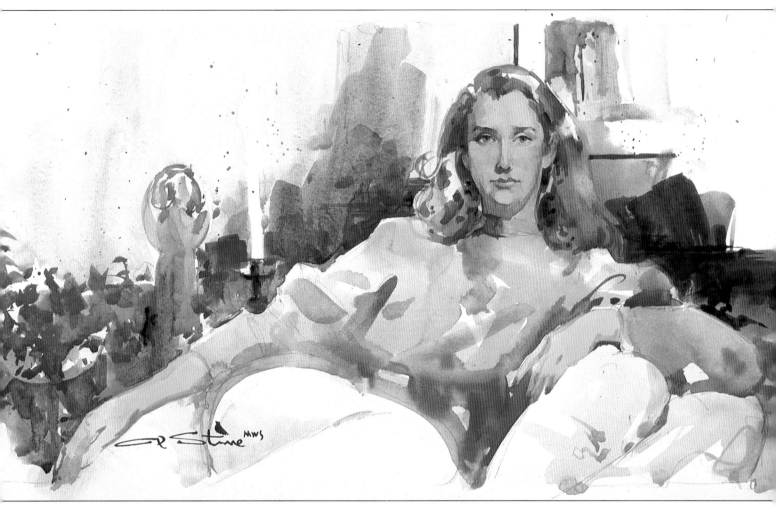

Catherine (13″ × 20″)

6 To finish, I added a few more mid-tone values. Wanting the head to be the center of interest, I added more darks to the hair and around the hair and shoulders, emphasizing the shapes and holding some edges. I also did some additional work on the eyes to make them more important.

PAINTING THE HEAD ON A TONED BACKGROUND

Many past masters of watercolor and oil painting used this method. This method tones the paper by laying down a light value wash and allowing it to dry thoroughly before beginning a painting. Oil painters use this first wash as their midtone value. They can then place darker and lighter values over it. Watercolorists don't have the luxury of using white, so this tone becomes our lightest value, and you must carefully plan to place your midtone and dark values. When I paint a head using toned paper, I usually paint the

wash in a warm, light skin tone. This will serve as the lightest value in my painting, and all other values have to be keyed to this. In using this method, you almost automatically establish good color harmony for the painting. It also gets rid of the white paper right away, which can be a deterrent for many painters.

You can buy toned watercolor paper in many different colors and tints, but I prefer mixing and applying my own color. However, when toning your own paper, there is the danger that the color

could be lifted when painting over it. One way to avoid this is to use waterproof ink to tone the paper. When dry, it cannot be disturbed or lifted. You must mix a *large* puddle of color and apply it with a large brush that is capable of holding a lot of liquid. I sometimes use what is called a *mop brush*. If you don't premix a lot of color to tone your paper and have to stop to mix more, you cannot get a flat wash. Sometimes I will wet the paper before applying the wash, but most often I apply the wash on dry paper.

I took this photograph of Dorothy at the Kanuga workshop.

As I often do, I made this photocopy from the photograph in order to better see the values and shapes of my subject.

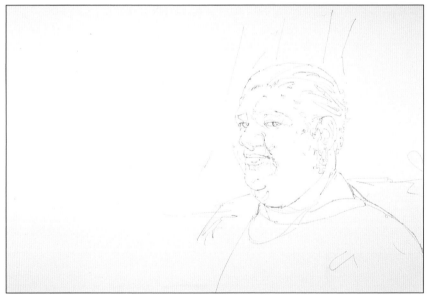

Sketch
Using the photograph and the photocopy, I completed this pencil sketch of Dorothy on Arches 140-lb. cold press.

1 I toned the surface of the paper with a light ochre color. Many oil painters do this to their canvas before beginning a painting. Toning the paper in this way makes for good color harmony; all the other colors used in the painting will be related to the surface color. I then allowed the paper to dry completely before going to the next step.

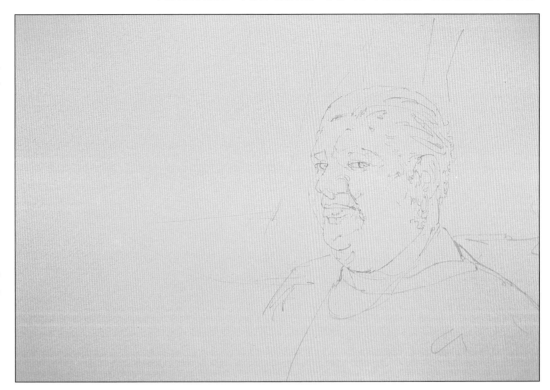

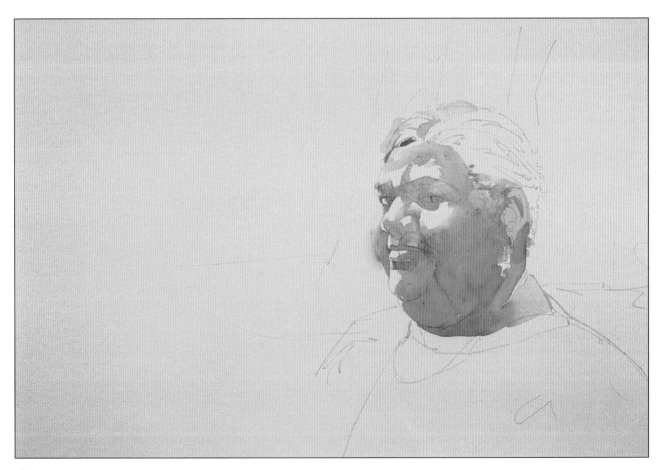

2 I used Yellow Ochre, Raw Umber, Alizarin Crimson, Cadmium Red and Cobalt Blue along with a little Winsor Violet to lay in my first light and midtone washes. I established the shapes in the shadows while leaving the tint of the paper as the lightest light.

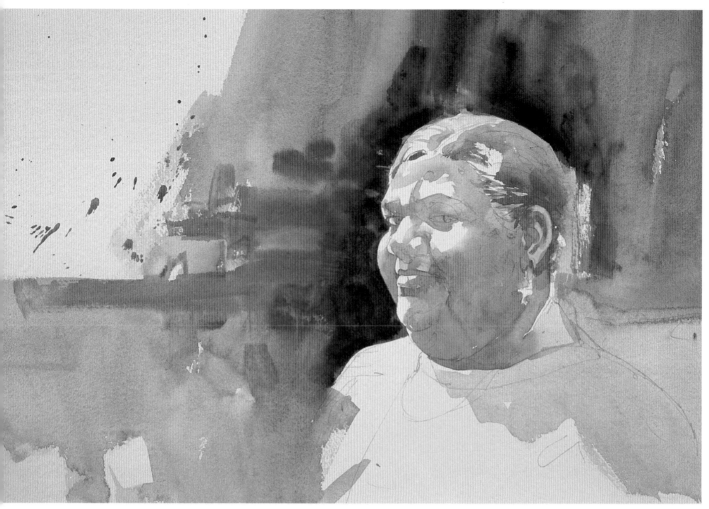

3 *I worked on the hair, moving the color beyond the hair-line and into the background since that area will be painted a darker value. I painted in the background holding the shape of the face, hair and torso. I also added some detail to the face and hair.*

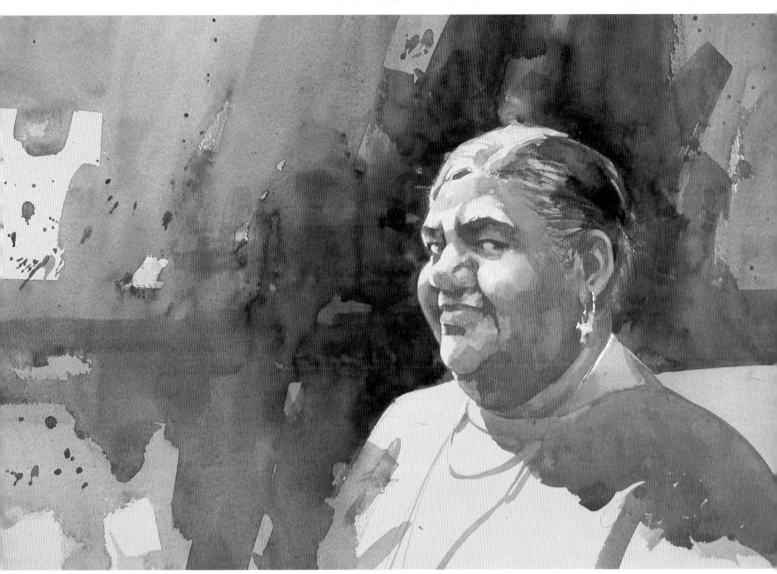

Dorothy (13″×20″)

4 *I completed the head by working on more detail and sharpening up all the features. I darkened the shadow on the shirt and intensified the colors and values in the background. As you can see, intensity of color and value around a figure brings it forward. Since I did not want the figure to look pasted on, I allowed the right side to blend into the background.*

FIGURE IN A VERTICAL FORMAT

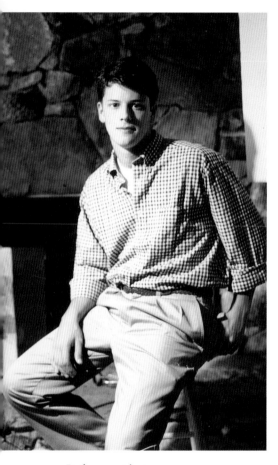

Reference photo.

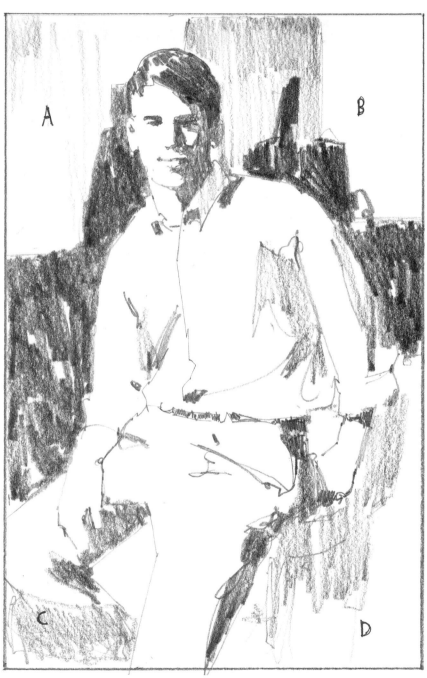

I do my own photography for my portrait work, but I also like to do several pencil sketches. This gives me the opportunity to talk with my models, getting to know their personalities—something that can seldom be captured by a camera. This drawing is based on the cruciform and on alternation: light against dark and dark against light. Each corner—A, B, C and D—is intentionally a different size and shape. This adds variety and interest to the drawing.

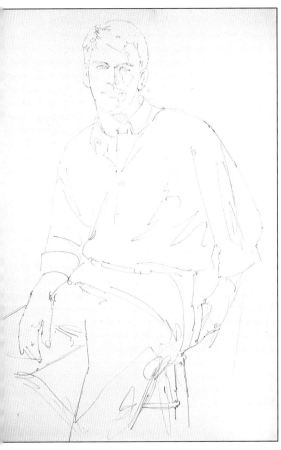

1 *I did this drawing on Arches 140-lb. cold press using both my photograph and sketches for reference.*

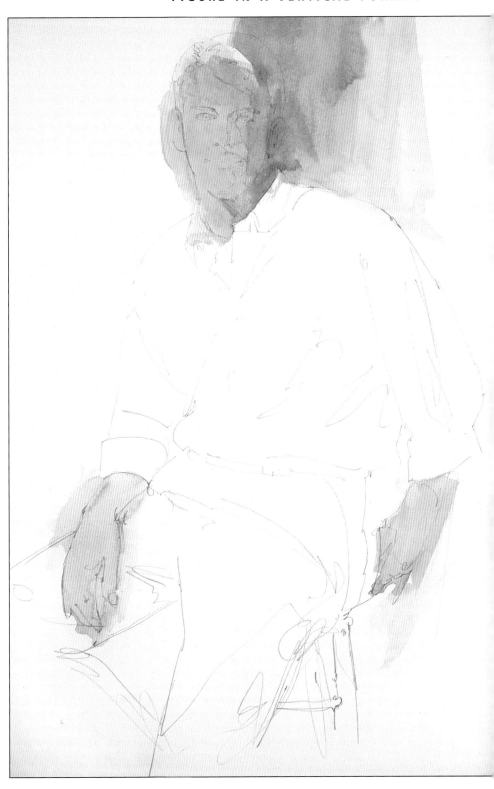

2 *I began the painting with a wash of Cerulean Blue. I painted the head with a mixture of Rose Madder Genuine and Aureolin, allowing the colors to mix on the paper rather than on the palette. I used more Rose Madder Genuine in the areas of the cheeks, nose and mouth to warm them up. I painted the hands using the same colors.*

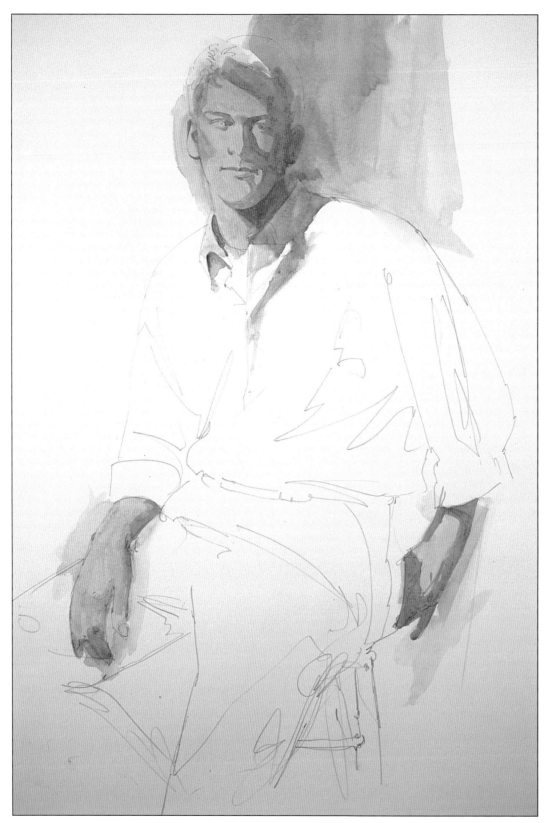

3 *I started painting the shadow areas and, to get the darker value, I substituted Yellow Ochre for the Aureolin. When I painted the area just below the chin, I added a little Cobalt Blue to the mixture for a cooler shadow. I again used the Cobalt Blue with Yellow Ochre to paint a cool area on the shirt.*

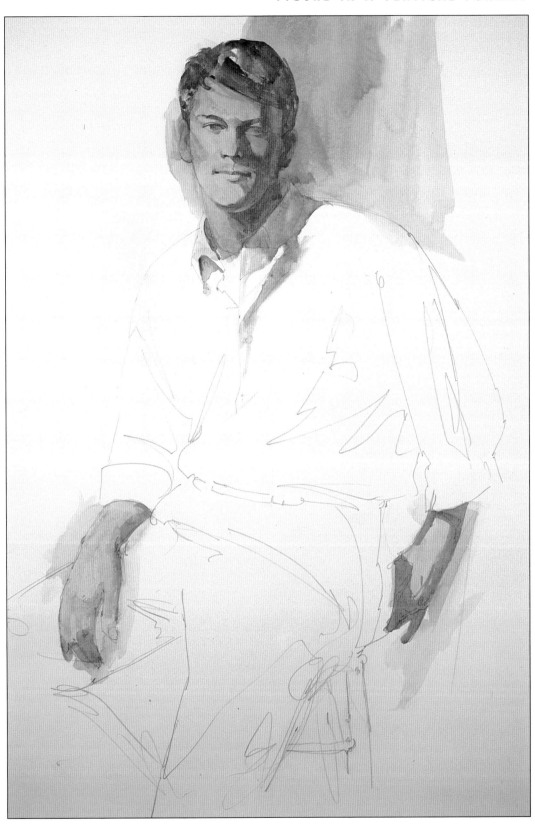

4 *I painted the hair using Rose Madder Genuine, Aureolin and Cobalt Blue. I began developing the features of the face and carried them to completion.*

Scott (20″ × 13″), in
the collection of Dr.
& Mrs. Carl Geier,
Anderson, South
Carolina

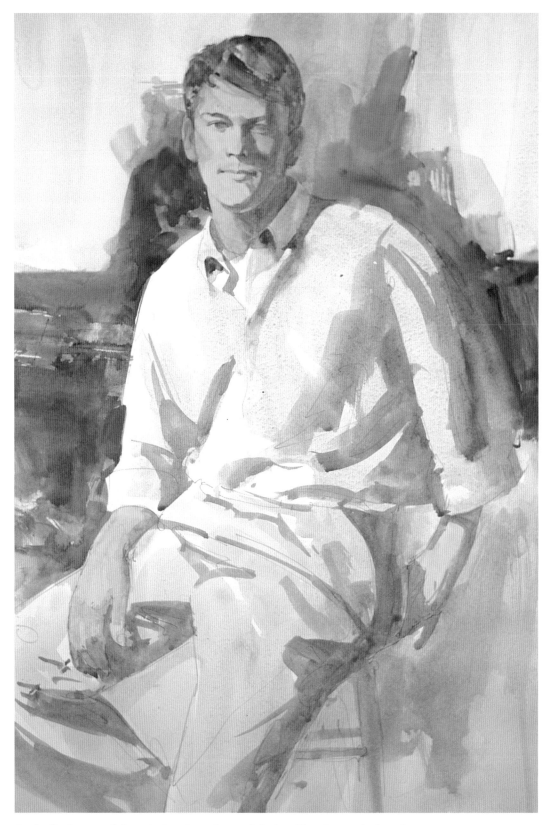

*In the final stage of the painting, I emphasized the head by placing darker shapes
around it. I finished the clothing, and then turned my attention to the back-
ground. For the lighter background values I used Aureolin and Cobalt Blue.
After these washes had dried thoroughly, I used deeper values of the same colors
for the darker areas. This painting has a fresh quality and the vertical format
suits Scott's pose.*

Archdeacon
(28″ × 20″), in the
collection of Mr.
& Mrs. Francis
Erckmann, Atlanta,
Georgia

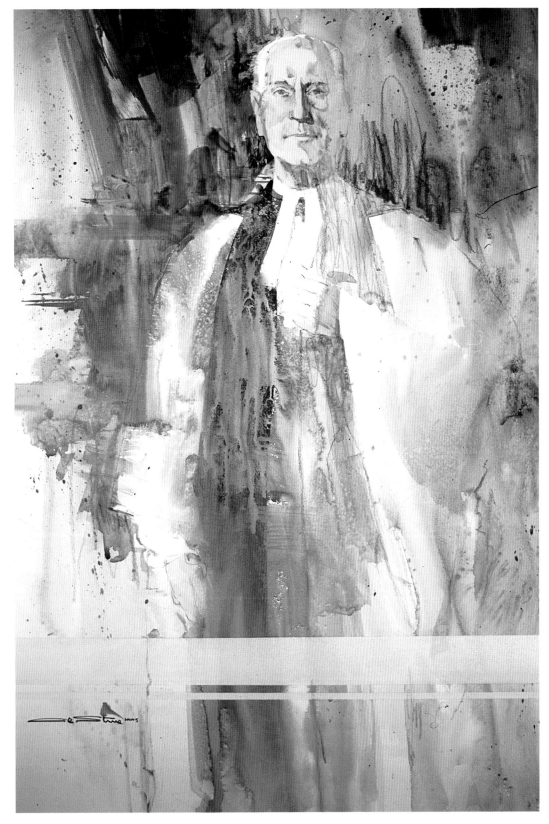

*This is a painting I did several years ago of a friend, a retired
archdeacon of the Church of England, who was kind
enough to don his vestments and pose for me. I chose to do
the painting in a vertical format to show the long, flowing
garments that are so much a part of him.*

ANOTHER VERTICAL POSE

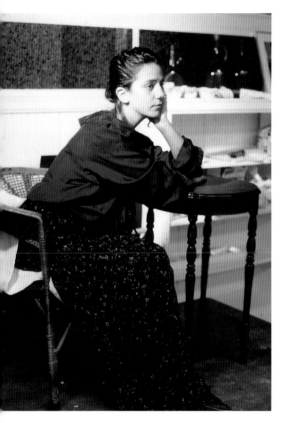

Reference photo.

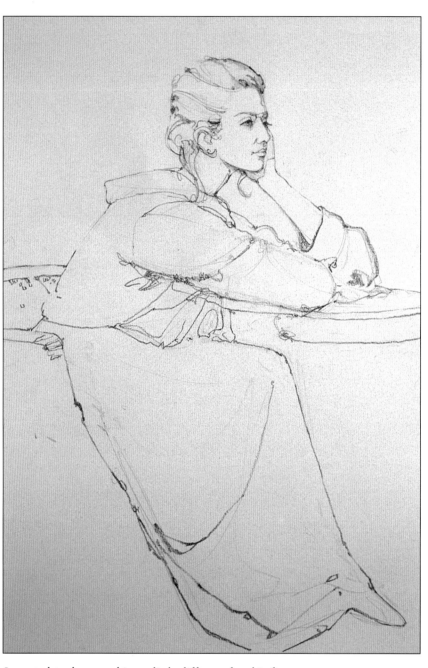

I wanted to do something a little different for this figure, so I did a charcoal drawing on tinted paper with the intention of painting over it with very transparent washes of color, creating a tinted drawing. It was important that the drawing was well executed since it would be the basis for the entire work.

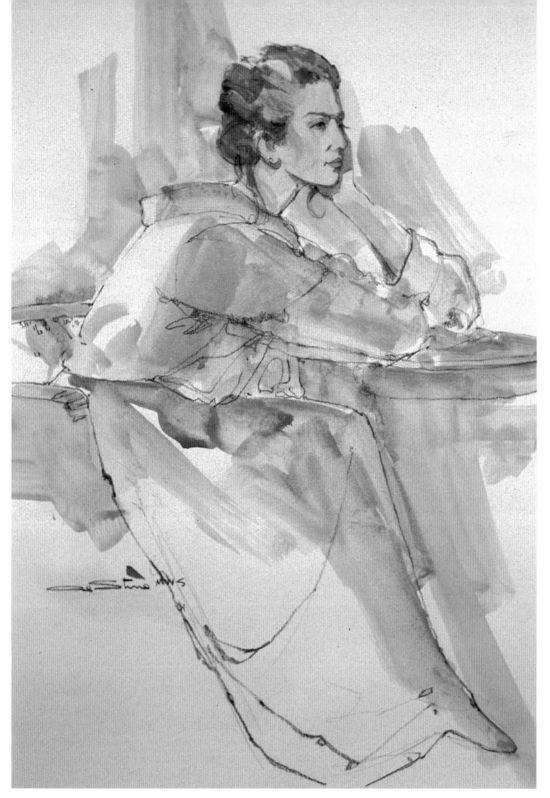

Cat (22" × 18")

First I painted a very light wash of skin tone using Alizarin Crimson and Yellow Ochre, allowing some to wash up into the hair and background. With French Ultramarine and Brown Madder Alizarin, I washed color into the hair. I used a little soap in this and all the following mixtures to get a different texture. The blouse is Permanent Rose, the skirt is French Ultramarine and I used Burnt Sienna for the table and chair. With a mixture of Yellow Ochre, grayed by a little bit of Ivory Black, I worked on the background. I added a little Winsor Blue in and over the eyes, and added Cadmium Red to the cheeks and lips. Finally, I darkened the hair with a deeper value of Brown Madder Alizarin.

USING BRIGHT UNDERTONES

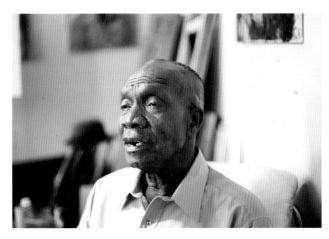

I took this photo of James at my workshop in Charleston, South Carolina.

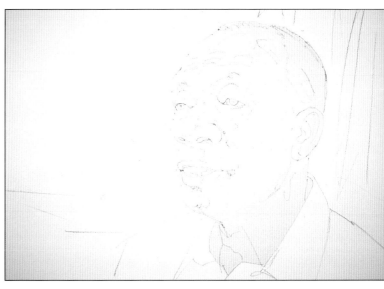

1 *In this pencil drawing, I indicated the shapes of the background as well as the head.*

The photocopy shows wonderful shapes and patterns as well as strong values.

2 *I used Raw Sienna, Alizarin Crimson, Cadmium Red and Cobalt Blue for this bright initial wash. This will serve as a bright undertone for the more neutral final color.*

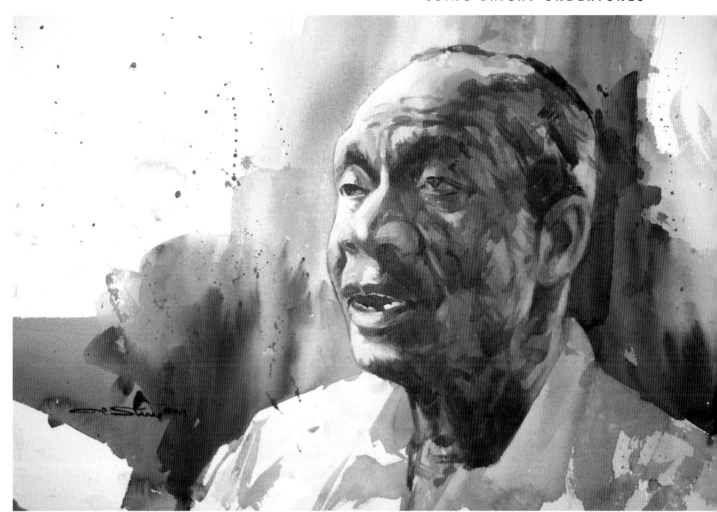

3 *I added the final skin tones and worked on the face to define the features. I brushed in the local color on the shirt and completed the background with values as dark as the shadows of the face. The background structures the white and the shape of the shoulders. I especially like the softness of the background where it contrasts with the harder edges.*

ASHLEY—A YOUNG WOMAN

I used a single source of light placed to the right at about ten o'clock to take this photograph, which I used for the following painting.

1 With the photograph as reference, I did this drawing using the cruciform design. Although it is somewhat detailed, I kept it loose. After the drawing was finished, I stapled the paper to a board in order to control most of the buckling. I did not soak and stretch the paper because I didn't want to remove the sizing. I used all three colors to paint the shape of the eye to the lips.

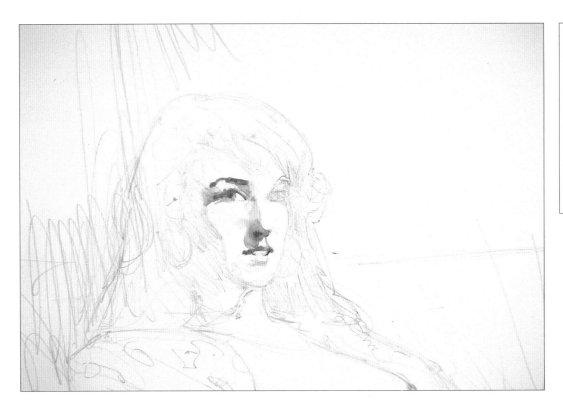

Detail of the head.

Palette
Rose Madder
* Genuine*
Aureolin
Cobalt Blue

Surface:
Strathmore
* 2-ply Plate*
* Finish*
* Bristol*
* Board*

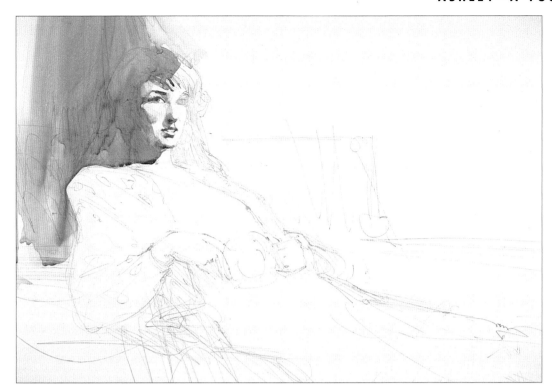

2 *I painted the shadow shape on the left side of the face, carrying the color into the hair and background, softening the outer edges.*

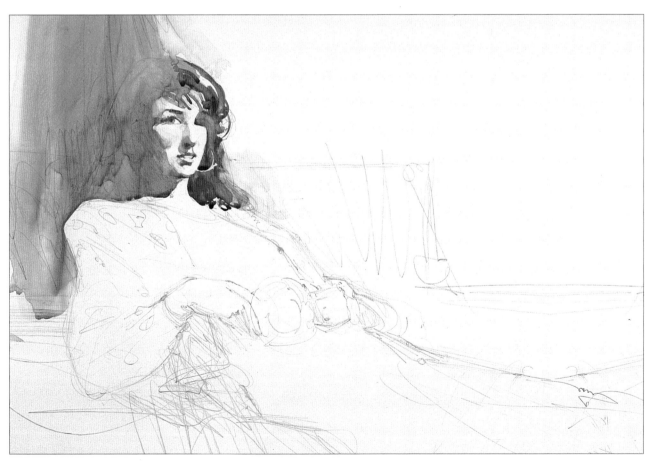

3 *When painting the socket area of the right eye, I carried the mixture into the hair, softening some edges into the background while maintaining a hard edge along the side of the face.*

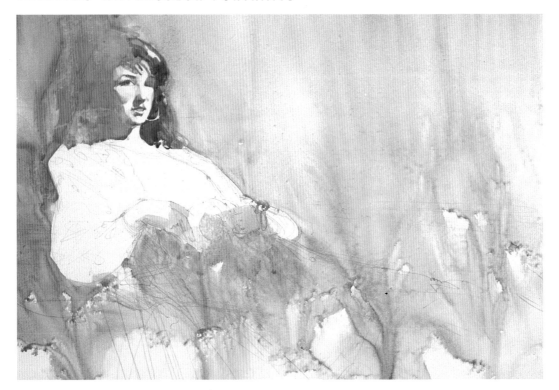

4 *I applied a mixture of the three colors to the background to get a nice warm gray. I sprayed water onto the area letting the color run down for an interesting texture that created both soft and rough edges. When the paper had dried completely, I added more Rose Madder Genuine to the mixture and brought the color down on the left to define the edge of the jacket and hands. I sprayed all of this with clear water, allowing the color to run once again and getting some interesting edges, then allowed the painting to dry.*

5 *Using the same colors in much darker values, I painted the shape of the dress, leaving the hard edges to define the shape of the hands. I softened the other edges with a wet brush and by spraying with clear water. Once again the painting had to dry thoroughly before I continued.*

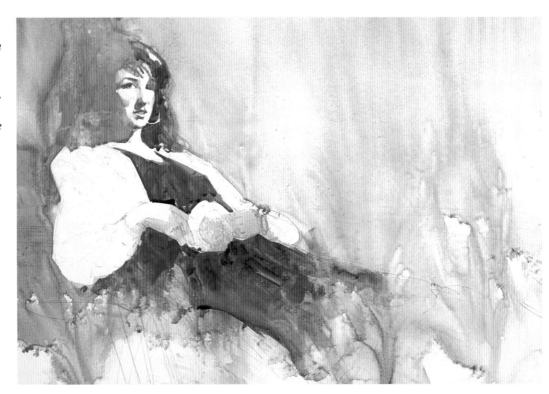

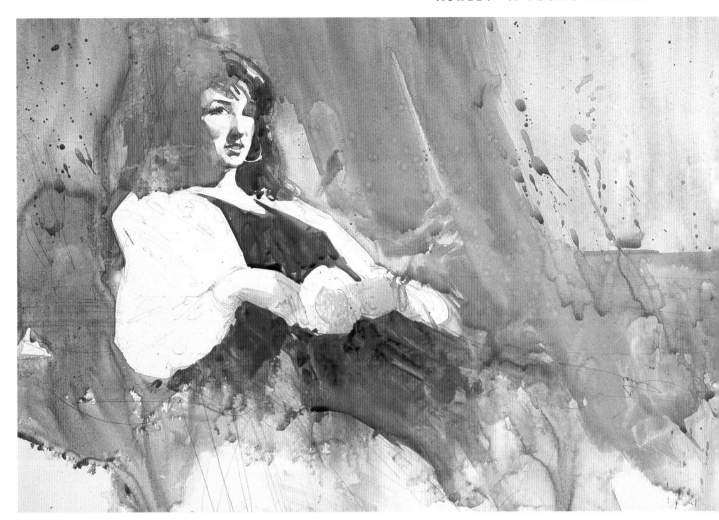

6 The large midtone area of the background to the right of the figure was too flat. With a darker midtone value of the three colors, I made some oblique passes with a flat 1½-inch brush and then carried the color across the paper in a horizontal passage. I added spattering for texture and allowed the paper to dry.

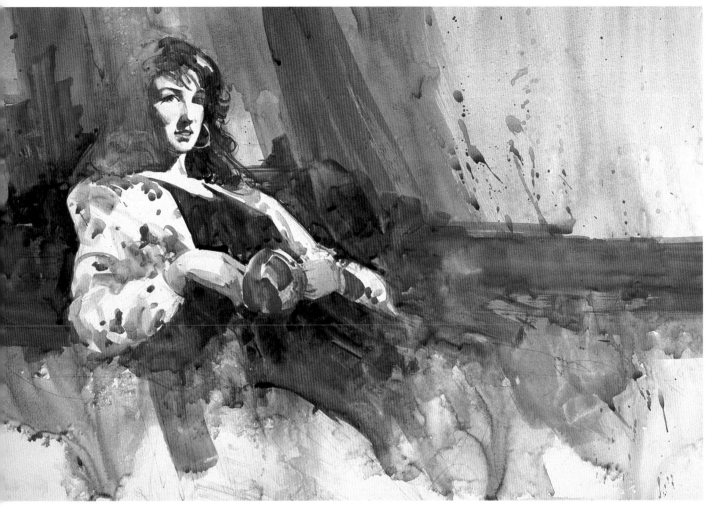

7 The painting began to take shape at this point, but I needed some darker values in the background to hold and define the edges of the jacket. I also wanted to carry the darker values of the dress out into the horizontal bar. I added a darker oblique passage to the right of the figure, darker areas just below that, and a few darker strokes in the horizontal bar. I also added a darker passage to the left of the figure, painted a design on the jacket, and did a bit of modeling of shapes on the hands. Wanting to get a hotter pink for the flower than I could get with Rose Madder Genuine, I added a touch of Permanent Rose. I did a bit more work on the head, kicking up the values on the edge where the dark shadow shape meets with the light area on the left side of the face. I added some detail to the hair and applied more darks in the background to define an edge for the hair.

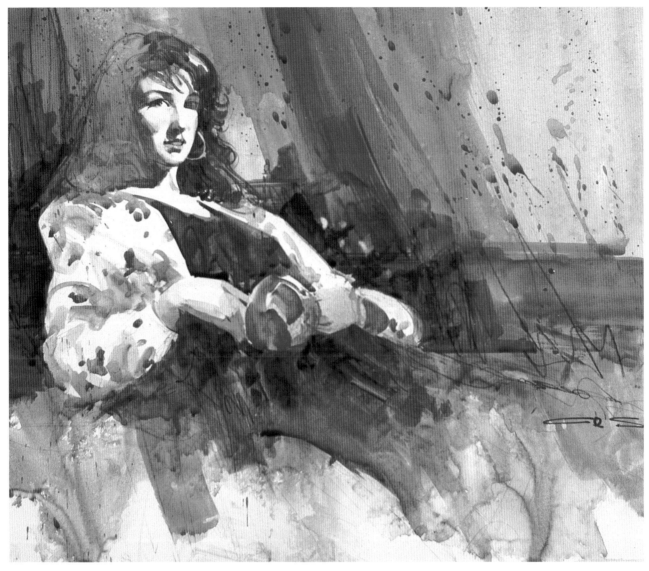

Ashley (13" × 20")

8 I further developed the darks in the background and used sharper chiseled shapes to contrast with all the softer passages. With a 4B charcoal pencil I defined the shape of the hair on the left and added some strokes to the background to achieve a looser feeling. Finally, I did a bit more spattering and lifted a few highlights with a damp brush for added excitement.

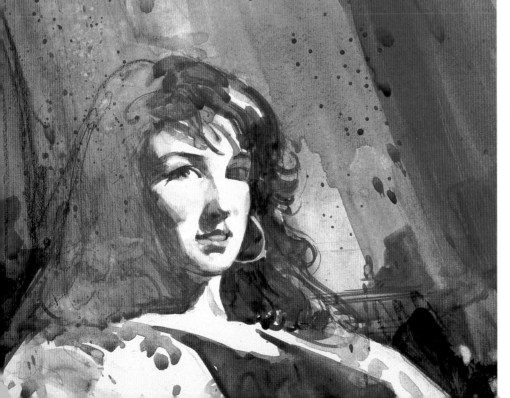

Detail of the head.

NORM: PAINTING GRAY HAIR

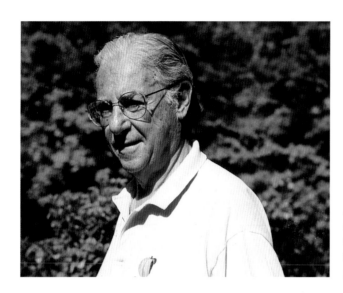

I took this photograph outdoors fairly early in the morning. You can obtain very good shapes with the light at this time of day, although it might get a little dark in the shadow areas.

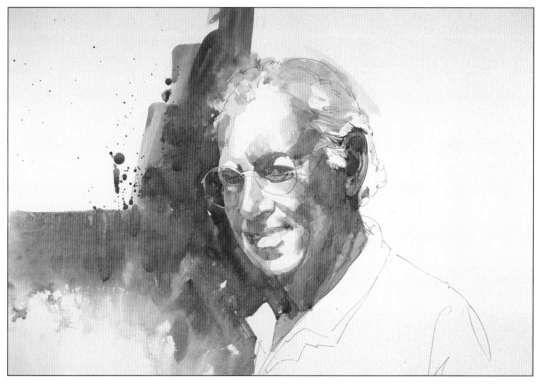

Palette

Rose Madder Genuine
Aureolin
Cobalt Blue
Surface:
Arches 140-lb. hot press
 paper

1 *I did not soak and stretch the paper since soaking would remove too much sizing and make it act like blotter paper. I painted the shadow areas of the face with light and midtone values, leaving the white of the paper to act as the lightest lights. I applied a light value of Cobalt Blue for the hair, then started on the background so that I could key my values better. I used fairly dark values on the left side of the head, keeping them very transparent. Painting this part of the background gives me a better idea of where to go with my darker values on the head. I then sprayed the lower area with clear water to get texture. Next, I did a little more work on the face with a no. 8 round, laying it on its side and dragging it while applying pressure. This makes it appear as if I used a flat brush. A lot of texture can be achieved with this method.*

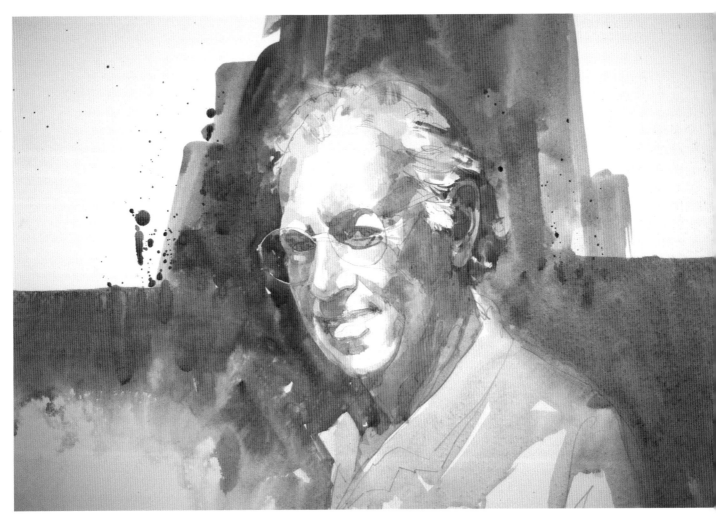

2 I worked on the hair and placed some of the background on the right side. I kept the background a mid-dark to contrast the white hair and shirt. Next I painted in the first flat washes on the shirt.

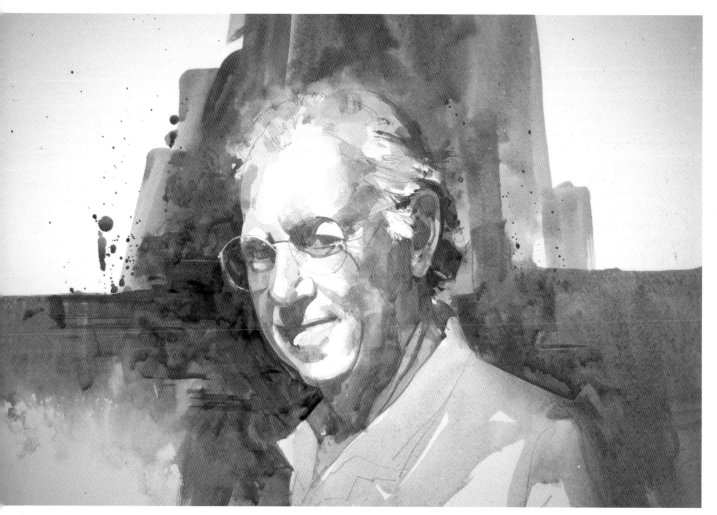

3 *I added more darks to the face to bring them up to the values of the background. At this point I changed over to a flat brush in order to get more chiseled shapes in the background. I also brought some of the warmer colors used for the face into the background to achieve greater harmony.*

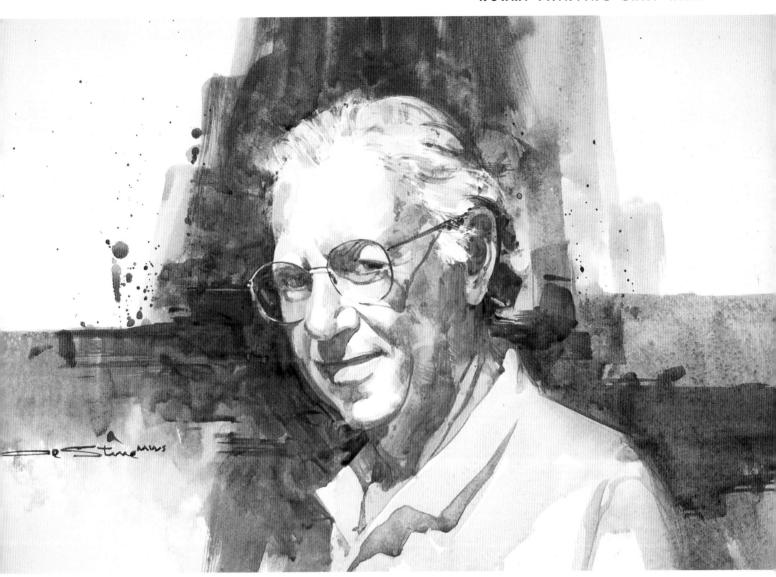

Norm (13″ × 20″)

4 *I added detail to the hair and darkened the background around it to hold the shape. I did a little more work on the face, balancing the values and defining the shapes to finish the painting.*

SALLIE—A DIRECT GAZE

Palette

Basic Colors:
*Permanent
 Rose*
Raw Sienna
Cobalt Blue
Incidental
 Colors:
Cadmium Red
Cerulean Blue
Raw Umber

1 *Starting with the eye on the lit side of the face, I worked the color down around the nostril and continued to the neck.*

2 *Using Permanent Rose and Raw Sienna, I began painting at the top of the head, taking the color right up into the hair. I continued the wash down to the neck, allowing the color to mix and mingle on the paper. I warmed up the areas around the nose and cheeks with Permanent Rose and a bit of Cadmium Red. I also painted the arms at this stage, allowing the colors to bleed beyond the pencil lines.*

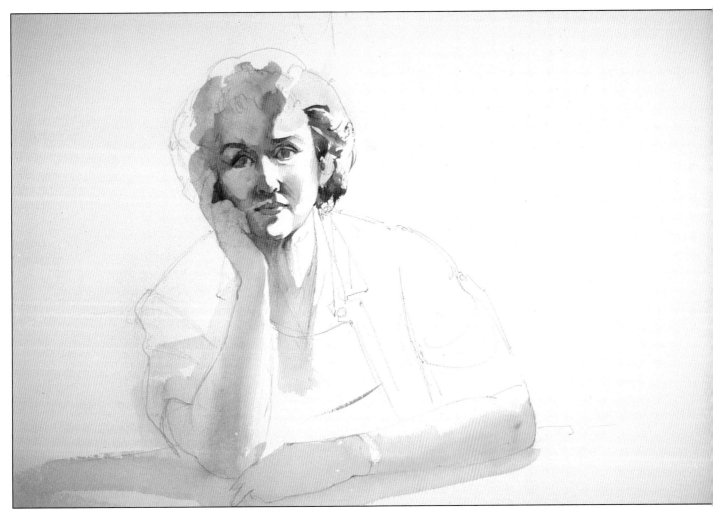

3 *I worked on the features, bringing the head almost to completion with the exception of the hair.*

4 I never try to go too far with a figure without doing some work on the background areas. I used Cerulean Blue for this wash and charged in a little Raw Sienna, then let the colors mingle.

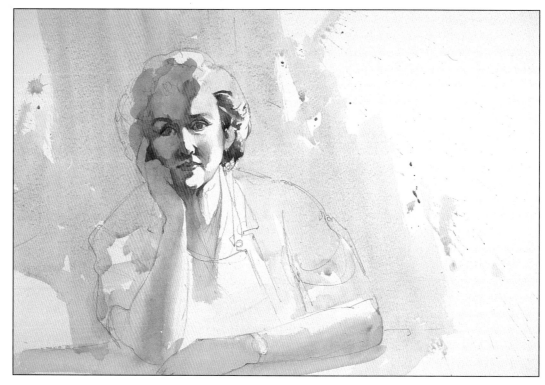

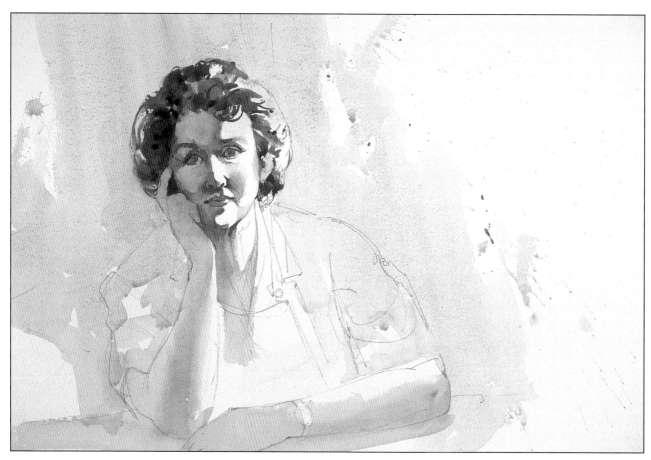

5 I painted the hair with a grayed blue-purple mixture using all three colors on my palette. For some of the brush licks in the hair, I laid my round brush on its side and dragged it across the paper, giving some interesting textures.

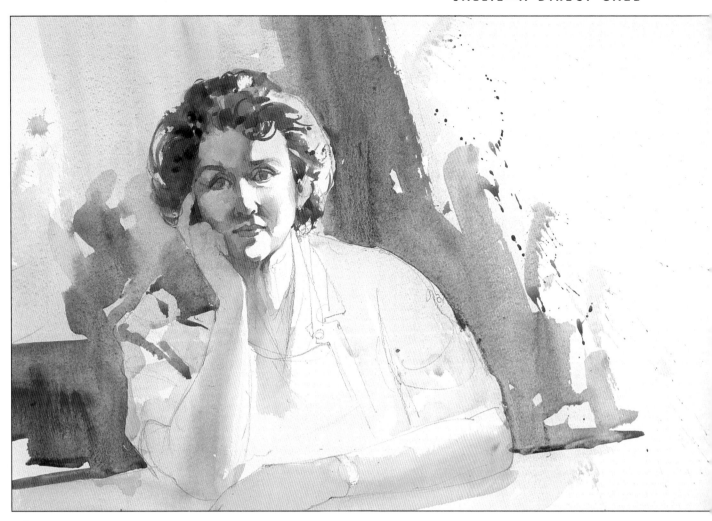

6 *I painted a deeper value into the background using Cobalt Blue and mingled in some Raw Sienna, which defined the highlighted area of the hair, shoulder and arm. To the left of the figure, I used the same Cobalt Blue mixture to indicate the shadow being cast on her shoulder, losing the edge into the background. At the bottom, I held the shape of the table with the same color.*

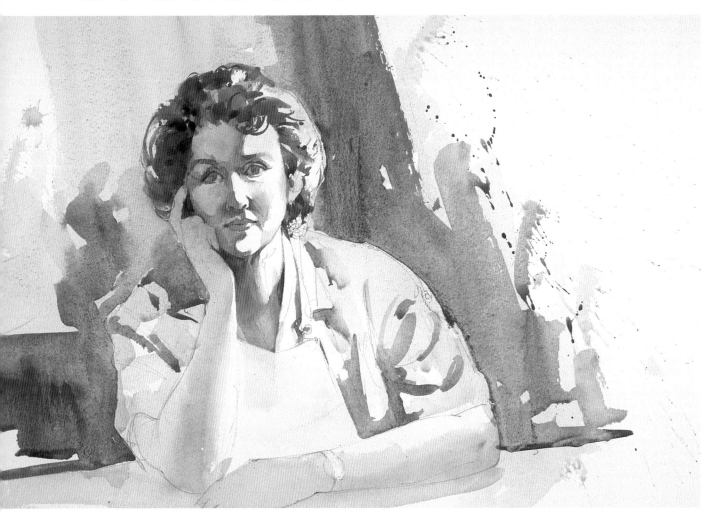

7 *I painted the dress indicating some folds and using the same Cobalt Blue mixture.*

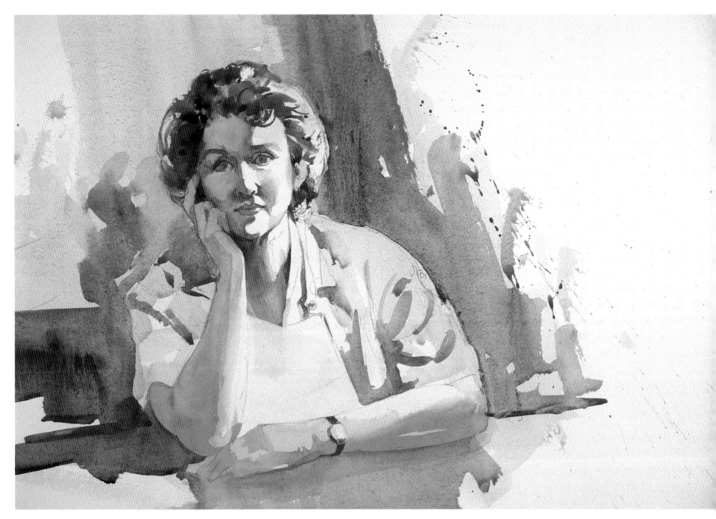

8 To develop more form, I worked on the arms and hands. While this wash was still wet, I used a Cobalt Blue mixture to create shadow on the tabletop in order to hold the shape of the arms. This allowed the flesh color to bleed into the blue, giving me a better transition along with a reflective quality on the tabletop.

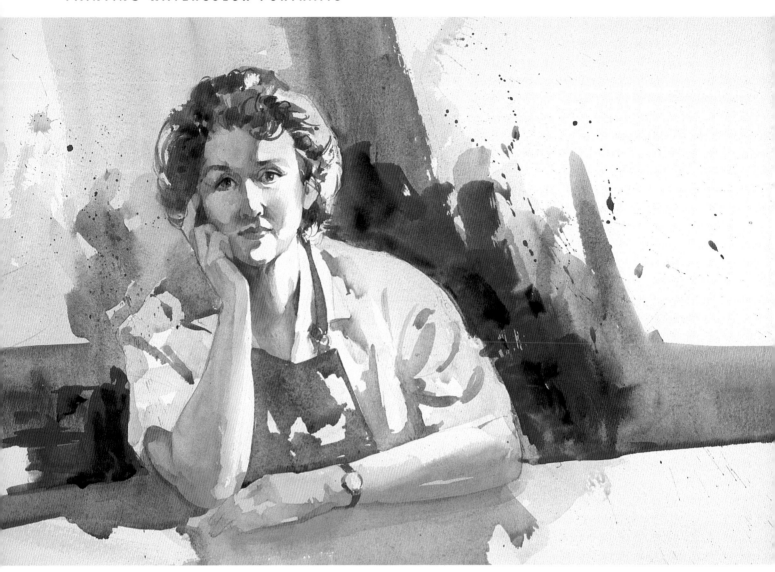

Sallie (13″×20″)

I extended the background shape to the right of the figure, which gave a better division of space. I intensified the value in this area and on the left, making the figure stand out a little more. This also made the lights appear lighter. Note that the vignette has a different shape at each of the four corners of the paper, and carrying the white of the vignette into the figure helped to better relate the figure to the background. I painted the apron and its strap with Cobalt Blue. While it was still wet, I mingled in some Raw Umber to gray it, creating a color different from that in the background. I added more detail to the eyes and used a razor blade to scratch out the highlights of the pupils. I added more darks in the hair to complete the painting.

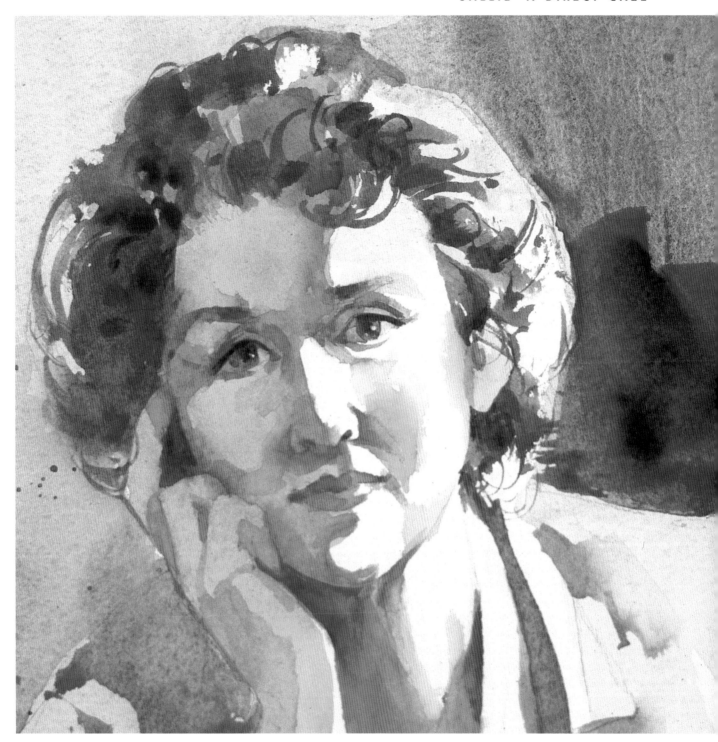

Close-up of the face.

MARGARET—PORTRAIT WITH BRIGHT CLOTHING

I took this photograph of artist Margaret Martin at the Kanuga Watercolor Workshops where we were both instructors. Her sparkling personality and colorful clothing made me want to do a painting of her.

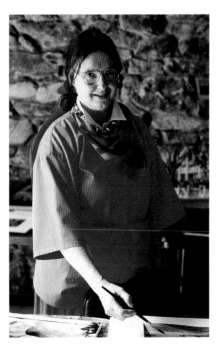

Palette
Basic Colors:
Alizarin Crimson
Raw Umber
Cobalt Blue
Bright Clothing Colors:
Opera
New Gamboge
Hansa Yellow
Cadmium Orange
Surface:
*Strathmore 2-ply Plate
 Finish Bristol Board*

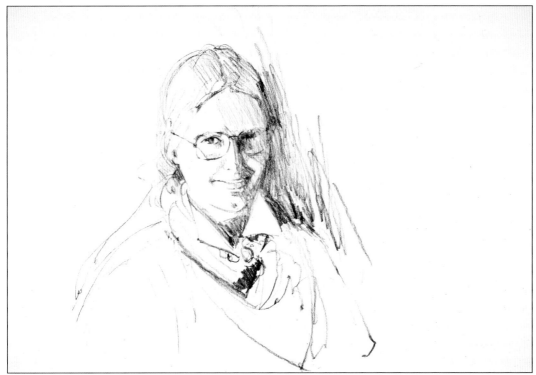

1 *I did this drawing with a 4B charcoal pencil on bristol board, using my photograph as reference.*

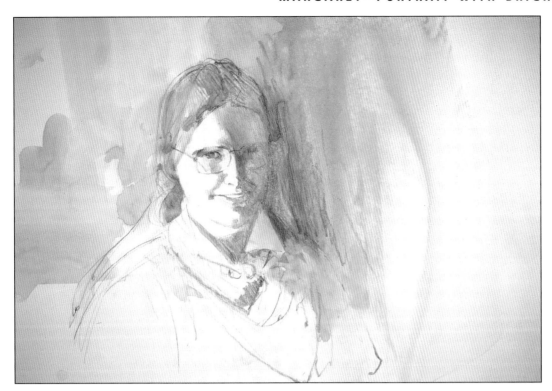

2 *I rolled a kneaded eraser over the drawing to pick up some of the loose charcoal and to lighten it. I then lightly sprayed it with a matte workable fixative so I would not pick up the charcoal when applying my washes. With a mixture of Alizarin Crimson and Raw Umber, I painted a wash over the background and the areas of the figure that were in shadow.*

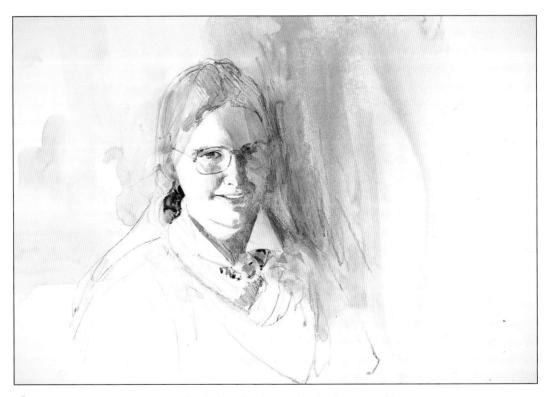

3 *Working on the face, I added a little red color to the cheek area and lips. I tightened up the drawing of the eye by using a much darker value of the same basic skin mixture, but adding just a little Cobalt Blue to darken it. I put some color on the necklace and added the dark touch to the hair to start keying in my darks. Then I toned the frame of the glasses with the point of my brush. Keep glasses light and simple. Make a single stroke, and don't go over it.*

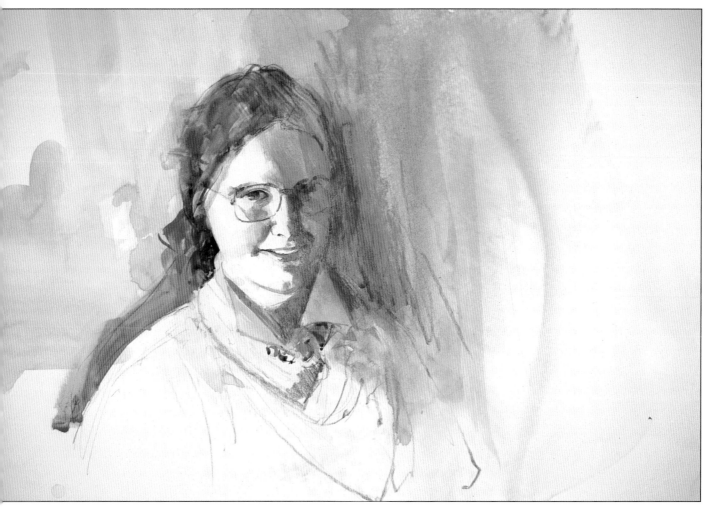

4 *I wanted a hot pink for the scarf in her hair, so I chose a color I seldom use, Opera. I used New Gamboge for the shirt collar in the shadow area and Hansa Yellow in the lit area. I added detail to the hair using Cobalt Blue and Alizarin Crimson.*

5 *I painted in the background with Cobalt Blue and Alizarin Crimson, letting the color soften into the scarf. I used Cadmium Orange for the blouse.*

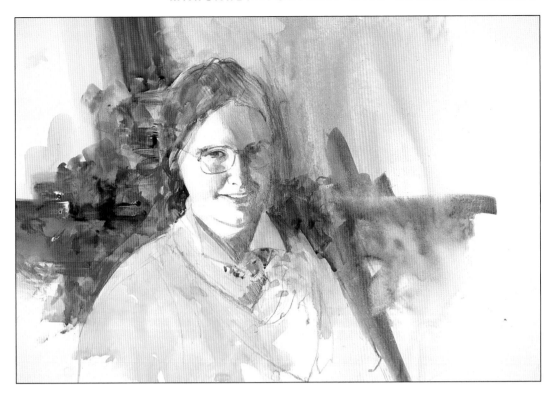

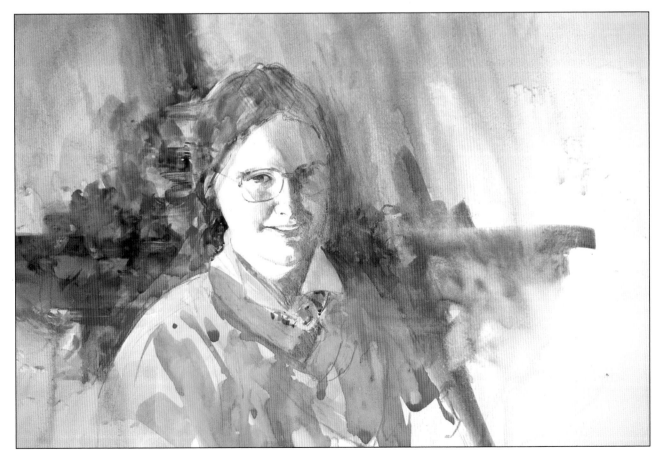

6 *I painted the shadow area of the blouse with a deeper value of Cadmium Orange. I added more pigment to the background, killing some of the white at the top of the painting (which had been bothering me) and sprayed some of it with clear water, letting the colors run down.*

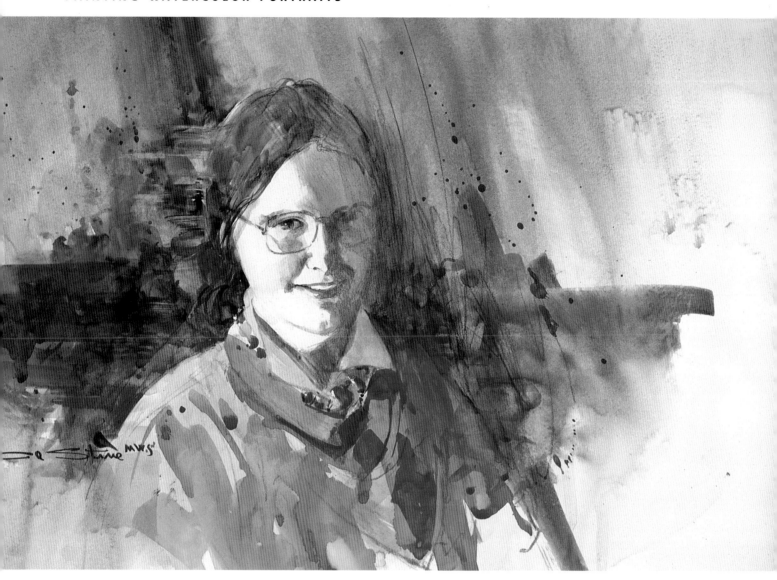

Margaret Martin (13" × 20")

7 *I added more Cadmium Orange with Alizarin Crimson for the dark areas of the blouse and did additional work on the hair on the left side. I did some spattering with a brush for added texture, and scratched out a highlight in the eye along with a couple of highlights on the necklace. For the last step, I used a charcoal pencil to loosen up the right side of the painting.*

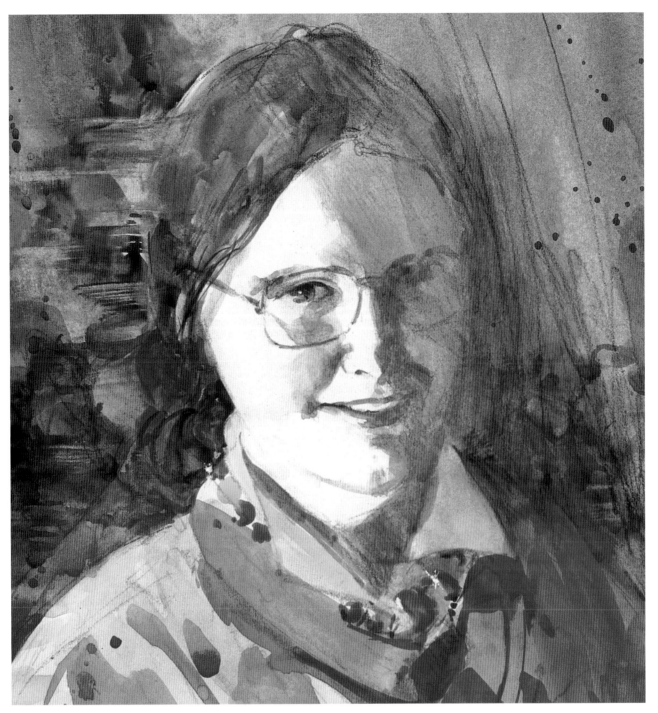

Close-up of the head.

BEARDED STEVE

I met this gentleman at an outdoor art and craft show where he was displaying his beautiful pottery. He had one of those faces I had to paint and he graciously allowed me to photograph him.

Palette
Skin:
Alizarin Crimson
Cadmium Red
Yellow Ochre
Cobalt Blue
Hair and Beard:
Cobalt Blue
Alizarin Crimson
Winsor Violet
Surface:
Arches 140-lb. cold press

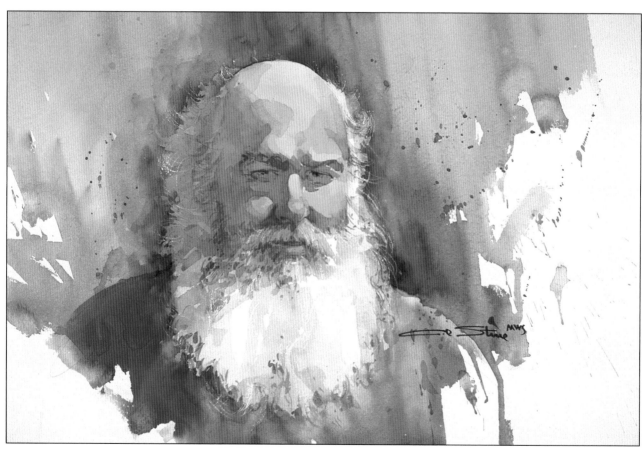

Steve (13″ × 20″) *After the basic skin colors were dry, I added Cadmium Red to the nose, cheeks and lips—normally the warmest areas of the face. Then I strengthened the shadow areas in the beard and hair, and scratched out some white hairs with a razor blade. When painting hair of any kind, avoid the temptation to overwork it by painting every strand. Try to simplify, leaving much to the viewer's imagination.*

BETTY RUTH IN SOFT LIGHT

The reference photo for this painting was taken in natural light from our breakfast room window. After laying in the background, I painted the face with a mixture that violated my cardinal rule of dark colors. I had used two semi-opaques and didn't like the result. Although I scrubbed the first attempt out, the sap green I had used remained since it is a powerful staining color. I then repainted the shadow areas of the face with my favorite triad of transparents. The results, especially over the sap green, gave the softness I was looking for. I kept all the colors subdued to keep the feeling of soft light.

Palette
Background:
Permanent Rose
Cobalt Blue
Skin:
Rose Madder Genuine
Aureolin
Cobalt Blue
Hair:
Cobalt Blue
Sap Green
Cadmium Red

Betty Ruth (14" × 20")

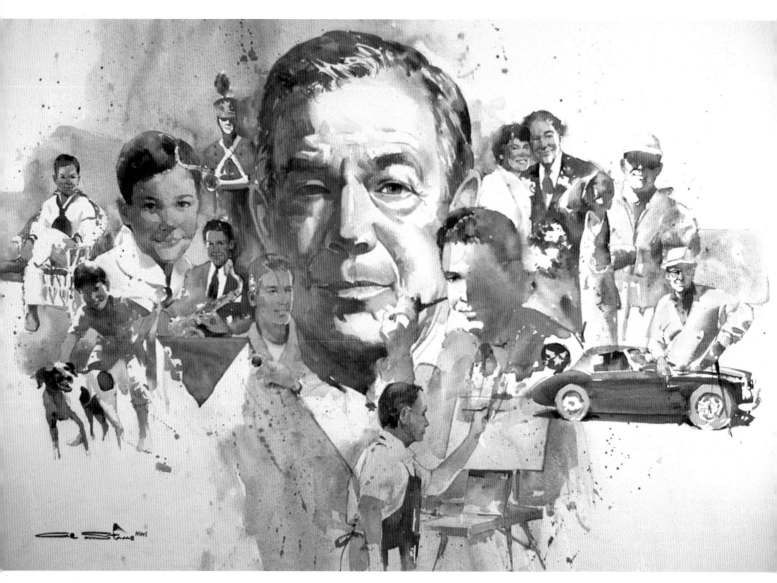

This is a self portrait that I painted using the cruciform design. I did the head quite large and just a little off center. Using pictures from our family photo albums, I created a montage of figures to tell a "story" of my life from early childhood to present. I painted the montage with many lost and found edges, so it would not overpower the large portrait that is the center of interest.

Conclusion

After you have read and digested this book, I hope you will have gained insight into drawing and painting the head and figure, and that you will be inspired to practice these skills on your own.

One piece of advice I would like to leave with you is to practice your drawing and painting every day. Make the effort to improve your drawing skills as they are the foundation of your work. Even after writing this book, I still faithfully attend my Thursday morning sketch class.

Whether you want to improve your work so that you can show and/or sell it, or you just want to do better paintings for your own satisfaction, the effort is well worth the time. Being an artist is a continuing process of learning and improving. I see it every day in my teaching. The artists who keep with it, practicing and painting as much as they can, invariably make great strides in their work. I hope you will be one of them.

Good luck with your painting and all my best.
Al Stine

Index

More Great Books for Beautiful Watercolors!

Basic People Painting Techniques in Watercolor—Create realistic paintings of men, women and children of all ages as you learn from the demonstrations and techniques of 11 outstanding artists. You'll discover essential information about materials, color and design, as well as how to take advantage of watercolor's special properties when rendering the human form. #30756/$17.99/128 pages/275+ color illus./paperback

Splash 4: The Splendor of Light—Discover a brilliant celebration of light that's sure to inspire! This innovative collection contains over 120 full-color reproductions of today's best watercolor paintings, along with the artists' thoughts behind these incredible works. #30809/$29.99/144 pages/124 color illus.

Painting Watercolors on Location With Tom Hill—Transform everyday scenes into exciting watercolor compositions with the guidance of master watercolorist Tom Hill. You'll work your way through 11 on-location projects using subjects ranging from a midwest farmhouse to the Greek island of Santorini. #30810/$27.99/128 pages/265 color illus.

Capturing the Magic of Children in Your Paintings—Create fresh, informal portraits that express the lively spirit and distinct personalities of children! In this book, designed to help artists in all the popular mediums, Jessica Zemsky shares the lessons she's learned in her many years of painting children—from finding natural poses to rendering varied skin and hair textures. #30766/$27.99/128 pages/130+ color illus.

1997 Artist's & Graphic Designer's Market: Where & How to Sell Your Illustration, Fine Art, Graphic Design & Cartoons—Your library isn't complete without this thoroughly updated marketing tool for artists and graphic designers. The latest edition has 2,500 listings (and 600 are new!)—including such markets as greeting card companies, galleries, publishers and syndicates. You'll also find helpful advice on selling and showing your work from art and design professionals, plus listings of art reps, artists' organizations and much more! #10459/$24.99/712 pages

How to Get Started Selling Your Art—Turn your art into a satisfying and profitable career with this guide for artists who want to make a living from their work. You'll explore various sales venues—including inexpensive home exhibits, mall shows and galleries. Plus, you'll find valuable advice in the form of marketing strategies and success stories from other artists. #30814/$17.99/128 pages/paperback

Becoming a Successful Artist—Turn your dreams of making a career from your art into reality! 21 successful painters—including Zoltan Szabo, Tom Hill, Charles Sovek and Nita Engle—share their stories and offer advice on everything from developing a unique style, to pricing work, to finding the right gallery. #30850/$24.99/144 pages/145 color illus./paperback

In Watercolor Series—Discover the best in watercolor from around the world with this inspirational series that showcases works from

over 5,000 watercolor artists. Each mini-book is 96 pages long with 100 color illustrations.
> **People**—#30795/$12.99
> **Flowers**—#30797/$12.99
> **Places**—#30796/$12.99
> **Abstracts**—#30798/$12.99

Painting Watercolor Portraits That Glow—You'll learn how to paint lively, accurate and brilliantly colorful portraits with in-depth instruction and detailed demonstrations from master artist, Jan Kunz. #30103/$27.99/160 pages/200 color, 200 b&w illus.

Jan Kunz Watercolor Techniques—Take a Jan Kunz workshop without leaving home! With 12 progressive projects, traceable drawings and Kunz's expert instruction, you'll paint enchanting still lifes and evocative children's portraits in no time! #30613/$16.95/96 pages/80 color, 60 b&w illus./paperback

Painting Realistic Watercolor Textures—Add depth, weight and realism to your art as you arm yourself with the knowledge to create lifelike textures and effects. A range of easy-to-do techniques are covered in a step-by-step format designed for both beginning and advanced painters. #30761/$27.99/128 pages/197 color illus.

Watercolor: You Can Do It!—Had enough of trial and error? Then let this skilled teacher's wonderful step-by-step demonstrations show you techniques it might take years to discover on your own. #30763/$24.99/176 pages/163 color, 155 b&w illus./paperback

Creative Watercolor Painting Techniques—Discover the spontaneity that makes watercolor such a beautiful medium with this hands-on reference guide. Step-by-step demonstrations illustrate basic principles and techniques while sidebars offer helpful advice to get you painting right away! #30774/$21.99/128 pages/342 color illus./paperback

Watercolor: Free & Easy—Make your watercolors come alive with energy as you learn the secrets of confident painting to make the most of watercolor's brilliant colors. In this exciting guide, Eric Wiegardt teaches you his secrets and techniques, including how to express yourself with rich color; how to make the most of "accidents" and much more! #30758/$27.99/128 pages/193 color illus.

Creating Textures in Pen & Ink With Watercolor—Create exciting texturing effects—from moss, to metal, to animal hair—with these step-by-step demonstrations from renowned artist/instructor Claudia Nice. #30712/$27.99/144 pages/120 color, 10 b&w illus.

First Steps Series: Painting Watercolors—Cathy Johnson tells first-time painters everything they need to begin—including which tools and materials to buy, explanations of watercolor terms and useful painting tricks. Easy-to-follow exercises will help you loosen up and learn the ins and outs of putting paint on paper. #30724/$18.99/128 pages/150 color and b&w illus./paperback

Painting With the White of Your Paper—Learn the secrets to creating luminous watercolor paintings and making the most of the paint's transparency and the paper's whiteness. #30657/$27.99/144 pages/181 color illus.

Painting With Passion—Discover how to match your vision with paint to convey your deepest emotions. With clear, step-by-step instructions, 15 accomplished artists show you how to choose a subject and use composition, light and color to suffuse your work with passion. #30610/$27.95/144 pages/225 color illus.

Splash 3: Ideas & Inspirations—You'll explore new techniques and perfect your skills as you walk through a diverse showcase of outstanding watercolors. Plus, get an inside glimpse at each artist's source of inspiration! #30611/$29.99/144 pages/136 color illus.

100 Keys to Great Watercolor Painting—Discover loads of tips for making your washes dry faster, correcting mistakes, creating soft glazes, loosening brushstrokes and more! #30592/$16.99/64 pages/color throughout

Creative Watercolor: The Step-by-Step Guide and Showcase—Uncover the innovative techniques of accomplished artists as you get an inside look at the unending possibilities of watercolor. You'll explore a wide spectrum of nontraditional techniques while you study step-by-step projects; full-color galleries of finished work; technical advice on creating professional looking watercolors and more. #30786/$29.99/144 pages/300 color illus.